THE BEST OF
THE GROUP OF SEVEN

THE BEST OF
THE GROUP OF SEVEN

Joan Murray
With an Essay by Lawren Harris

McCLELLAND & STEWART

Library and Archives Canada Cataloguing in Publication

Murray, Joan
 The best of the Group of Seven

Includes bibliographic references.
ISBN 13: 978-0-7710-2212-0
ISBN 10: 0-7710-6674-0

1. Group of Seven (Group of artists).[*] 2. Painting, Modern – 20th
century – Canada. 3. Painting, Canadian. I. Harris, Lawren,
1885-1970.

ND245.5.G7M87 1993 759.11 C92-095353-0

We acknowledge the financial support of the Government of Canada
through the Book Publishing Industry Development Program
and that of the Government of Ontario through the Ontario Media
Development Corporation's Ontario Book Initiative. We further
acknowledge the support of the Canada Council for the Arts and the
Ontario Arts Council for our publishing program.

Printed and bound in Canada

McClelland & Stewart Ltd.
75 Sherbourne Street
Toronto, Ontario
M5A 2P9
www.mcclelland.com

7 8 9 10 08 09 10 11

Contents

Acknowledgements/6
Seeing the Light: The Group of Seven and Canadian Art
 Joan Murray/7
The Story of the Group of Seven
 Lawren Harris/26
Members of the Group of Seven/33
List of Illustrations/35
Selected Bibliography/93
Photograph Credits/95

Acknowledgements

I fell in love with the Group of Seven in 1970 when I was Curator of Canadian Art at the Art Gallery of Ontario. My affection extended not only to Tom Thomson on whom I did a retrospective which travelled nationally, *The Art of Tom Thomson* (1971), but to all the Group. When a canvas by Lawren Harris in the collection of the gallery lost a chip of paint (I believe it was Harris's *Lake and Mountains*), I felt like all true curators, as though my face had been scratched. Hanging the works of the Group of Seven at the gallery was my education in their way of handling landscape, their strength of expression, and the powerful quality of their designs. I also received help in my studies from two shows by Dennis Reid. The first was his reconstruction of the first exhibition of the Group of Seven in 1920, which he held at the gallery in 1970; the second was his large Group of Seven show at the National Gallery of Canada in the same year.

In later years I followed exhibitions of the Group of Seven with interest and met and interviewed A. J. Casson, the last living member of the Group, as well as many friends and observers of the movement. Even when I became Director of the Robert McLaughlin Gallery in Oshawa in 1974, continuing my study of the Group seemed appropriate; the collection in Oshawa was primarily of the work of Painters Eleven, an abstract painters' group founded in 1953 in the hope of replacing the Group of Seven as the dominant force in Canadian art.

Since artists can often speak eloquently for themselves, I have included in this book Lawren Harris's story of the Group of Seven, taken from his extensive writings. I am grateful to his daughter, Peggie Knox of Vancouver, and his son, Lawren P. Harris of Ottawa, for permission to publish this material.

In choosing the works, I travelled to many public and private collections in the country. My travel resulted in many discoveries, among them: a Harris canvas, *Grey Day in Town*, thought to be missing by the curator of a major show of Harris's work at the Art Gallery of Ontario in 1978 (the painting was in the collection of the Art Gallery of Hamilton); the extraordinary beauty of Tom Thomson's *In the Northland*, newly cleaned by the Montreal Museum of Fine Arts. "The best" is a matter of taste. In my choices, I may have erred on the side of acknowledged masterpieces of the Group—they're masterpieces for a reason—but I have also included less well-known paintings because I loved them.

I am grateful to the curators and registrars who helped me to see the works of the Group in each location. Without them I could not have created this book. Robert Fulford has made helpful suggestions about my text. The staff of the Robert McLaughlin Gallery, as always, provided the assistance required by a project of this magnitude.

Joan Murray, Director
The Robert McLaughlin Gallery, Oshawa

Seeing the Light: The Group of Seven and Canadian Art
Joan Murray

Nearly sixty years ago Emily Carr met the Group of Seven. Her reaction was twofold. On her meeting with Arthur Lismer, shortly after meeting F. H. Varley and A. Y. Jackson, she wrote in her journal, "I wonder if these men feel, as I do, that there is a common chord struck between us." "No," she replied to herself, "I don't believe they feel so toward a woman."[1]

Although Carr could be over-sensitive, this time her doubt over whether she would be accepted was realistic. The Group did not count a woman among its magic seven, nor did it add one among the three members it included later. It was essentially a grown-up boy's club. The boyish atmosphere extended to the kind of paintings the Group produced. They are full of a boy's-story search for a site, in a manner less like Monet's constant quest for motif than like the Hardy boys' adventures. To this male preserve women were not admitted until 1933, when the Group expanded to include nearly thirty members. At the same time the name changed: the Group of Seven became the Canadian Group of Painters.

However, Carr's feeling of being swept away suggests Harris's—and the Group's—significance in Canadian art. As Carr said, they were the trail-blazers, she the disciple who must follow. Despite what she felt might be a lack of recognition from her mentors, meeting the Group put her on her mettle; her work from the time of the meeting demonstrates that. After 1927 she painted the major works of her career, at first Group-influenced (especially by Harris), and then in her own inimitable, soaringly expansive style.

Carr's rapturous reaction to the Group is felt by few Canadian painters today. Although Painters Eleven, formed in 1953, thought of themselves as the new Group of Seven (hence their playing with the name), they forgot the connection almost immediately upon their formation. Since the 1970s, only middle-aged painters such as Gordon Rayner and Graham Coughtry have spoken of the Group with affection. They especially admire Tom Thomson. Rayner praises Thomson's innovative colour and touch, "both aggressive and gentle, tough and sensitive." Thomson captured the unique light of the Pre-Cambrian Shield, Rayner says, the light Rayner himself has sought to convey.[2] Coughtry feels Thomson is among his favourite painters, "simply because of his painterly way of painting." He also admires Harris: "He's a major painter anywhere." When he was younger, Coughtry said, "Every damn tree in the country is painted, and that's my reason for painting the figure." Now that he lives in the country east of Toronto, Coughtry finds himself recalling Harris at moments when the land is white and grey. "They're the closest we've ever come to having some kind of romantic heroes in Canadian painting," he says of the group.[3]

To younger painters, the Group of Seven seems removed from their own concerns. Only painter and print-maker Arnold Shives in Vancouver has found their imagery in his work (often

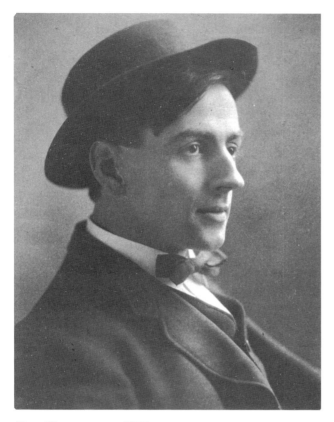

Tom Thomson, c. 1908
Ontario Archives, Toronto
#S2794

Thomson, although he died in 1917, was the soul and spirit of the later Group.

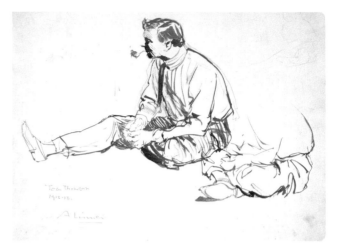

Arthur Lismer
Tom Thomson, c. 1912-1914
Ink on paper
22.8 × 30.5 cm
McMichael Canadian Collection, Kleinburg

Lismer worked with Thomson at Grip Ltd., then at Rous & Mann, commercial art firms of the day. This quick pen sketch shows what Jackson described as Thomson's "indolence."

of birches in snow). Toronto painter Rae Johnson used Georgian Bay as a setting for one of her large dramatic figure works, *Father and Son at Sunset* (1983): it has a Group setting and bold sunset view.[4] As with Rayner and Coughtry, Thomson and Harris are the ones who count for her.

These painters' use of the Group as only a touchstone or brief reference point marks a sharp difference from the 1930s when members of the Canadian Group of Painters like Isabel McLaughlin, Pegi Nicol MacLeod, and Anne Savage were influenced by the Group and spent their early years painting the Group's basic subject-matter, the Canadian landscape. As Savage said, "Our artists are still out on the Loon Lake portage confronting the rocks and the black bears. The Group of Seven led them there thirty years ago."[5] Establishing an identity in the face of the Group was the primary problem in the life of a Canadian painter until the 1950s.

In retrospect, the Group seems barely to have even been established. The movement is said to have begun in May 1920 at its first exhibition. The last exhibition was in December 1931. It therefore had an identifiable existence of one decade.

But many, if not all, of the members believed that the Group existed without the name ten years earlier. Harris, Jackson, Lismer, J. E. H. MacDonald, Varley, Frank Johnston and Franklin Carmichael, the youngest, persisted in remembering Thomson (who died in 1917 before the

Group formed) as a member; the movement was due to him if it was due to anyone, they felt. Lismer believed that the first traces of Group subject-matter occurred in Thomson's work in 1912, his timid but true-to-life sketches painted in the Mississauga country north of Georgian Bay. For Lismer and Harris the north country was the landscape crucial to the ethos of the new Group, and Thomson's way of painting the country provided a *modus operandi*. "We all saw that fall when he came back, that not only was Tom opening up as a painter, but that the northland was a painter's country," Lismer said.[6]

Harris also believed the outbreak of the new movement occurred in 1912, but he associated the spirit of the fledgling Group with an exhibition that year in which he discovered the affinity of his own work with MacDonald's.[7] Through Mac-Donald, he met the painters at the office where MacDonald worked, the commercial art firm of Grip Ltd.: Thomson, Lismer, Varley, Carmichael, and Johnston. Again, Thomson is the thread connecting the early members to the new landscape: the landscape led to the idea of the Group.

Behind the Group is another factor: the growth of Toronto, the city that was soon to be one of the largest and most significant both in the business and cultural life in Canada. In 1910 Toronto was going through one of the most exciting times in its history: the city was expanding at an enormous pace, due to a series of eight annexations which began with North Rosedale in 1906.[8] (By the time of the First World War it had reached approximately its present size.) At the same time, the city was sorting itself into quarters. One of these, the Ward, became a favourite subject of Harris's work in this period. As a working class area, it offered an exotic, colourful contrast to the place where he'd gone to boarding school, Rosedale, the home of Toronto's rich. (Harris's father, Thomas Morgan Harris, was secretary of A. Harris, Sons & Co. Ltd. which amalgamated with Massey to form the Massey-Harris Company.)

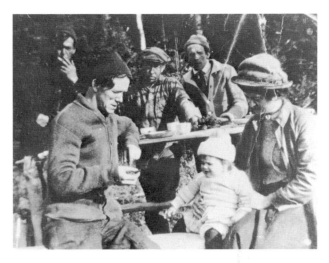

Algonquin Park, October 1914
From left to right: Tom Thomson, F. H. Varley, A. Y. Jackson, Arthur Lismer, Marjorie Lismer, and Elizabeth Lismer.
Art Gallery of Ontario, Toronto

The fledgling Group discovered Canada's North Country by camping as well as painting in it. Thomson and Jackson were excellent woodsmen, as their outfits show; Lismer was more citified—he wears a tie.

Painting the Ward was the way Harris recorded the growth of the city he loved. His decision in 1913 to found the Studio Building with Dr. James MacCallum was another way of changing the city. The three-story building on Severn Street, within walking distance of Bloor and Yonge, provided inexpensive studio space for fledgling Group members, and along with MacCallum's purchases, encouraged commitment. Together with Thomson, Jackson, and MacDonald, Harris believed the new Group would be able to combat Toronto's famous conservatism. ("Toronto the Good" was only one of its nicknames.) Harris delighted in the lively cultural scene of the day, the lunchtime meetings of the Arts & Letters Club, and the formal opening of such cultural institutions as the Royal Ontario Museum in 1914 (the

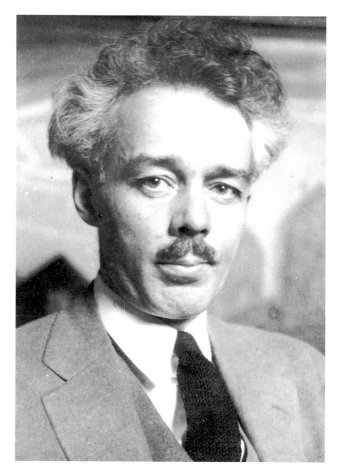

Lawren Harris, c. 1920-1925(?)
Art Gallery of Ontario

Harris was the handsome, charismatic, but unofficial leader of the Group of Seven. His eyes show his intelligence and humour. Many acquaintances remarked on the casual elegance of his clothes.

Arthur Lismer
Lawren Harris, March 1920
Charcoal on paper
25.4 × 20.2 cm
Art Gallery of Ontario, Toronto
Gift of Mrs. R. M. Tovell, 1953

The Group got its name at Harris's house one night in March 1920. At the meeting Harris sprawled in a wicker chair in the living room with his feet up, completely relaxed (he was double-jointed). His face shows the disgust that he may have felt for the societies like the Ontario Society of Artists and the Royal Canadian Academy. At the same time, his pose suggests his powerful, energetic nature.

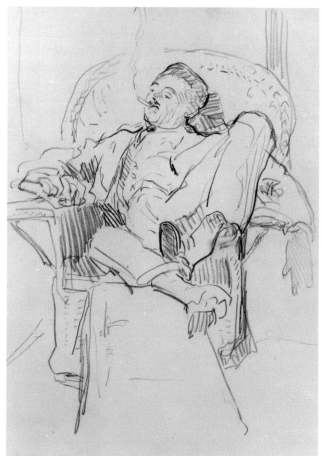

Art Museum of Toronto, later the Art Gallery of Ontario, was founded in 1908).

The First World War meant an end to Harris's optimism. Not only did many of his friends enlist, as Harris did himself in 1916, but he found himself isolated, teaching musketry (and hating it) at Camp Borden, near Barrie, Ontario, the largest permanent Army and RCAF camp in Canada.

The war changed Harris's way of thinking about what he wanted to paint. He wanted to express what he felt about Canada, using a "more creative and magnificent communion than a communion of war." The art produced must be "on a grander scale than anything hitherto attempted, heroic enough to stir the national pulse when the stimulus of struggle had been withdrawn," Harris said. Despite these plans for the future, he felt tremendous strain under the discipline of the war machine.[9] Late in 1917 he had a nervous breakdown. The death of his brother, Howard, early the following year, after being awarded the Military Cross for heroism in Europe, added to Harris's massive depression.

When Harris recovered from his breakdown, he made an exploratory trip to Algoma with his friend MacCallum. He then outfitted a freight car as living quarters and took along kindred spirits among the painters, notably MacDonald, on a serious painting trip. This trip, and successive trips to the same area, developed the Group's sense of community spirit. By 1920, they were ready for a more unified effort.

Harris's reaction to 1914-1918 was characteristic of many Canadians of the period who responded to the futility of war with a desire to discover what constituted Canada. In the early 1920s, *The Canadian Forum*, later the voice of the intellectual left, carried a number of articles on the subject, notably by E. H. Blake and J. S. Woodsworth, who later founded the CCF.

Harris's discovery of Canada seems not unlike that of activists like Woodsworth. Only a new and properly organized group could make a new Canada work, he and others believed; for this enterprise, Harris had the necessary enthusiasm, knowledge, and money. Unofficially, he became the Group's leader.

Jackson, the second-in-command, attests to Harris's position. He "provided the stimulus," Jackson said. "It was he who encouraged us always to take the bolder course, to find new

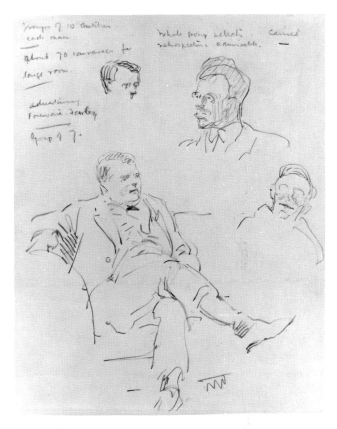

Arthur Lismer
Johnston, Carmichael & Varley, March 1920
Charcoal on paper
25.4 × 20.2 cm
Art Gallery of Ontario, Toronto
Gift of Mrs. R. M. Tovell, 1953

Lismer's sketch records the discussion which occurred the night the Group was named. There was some sort of order to the meeting. "Carried," Lismer noted at the top. Varley's expressive face, his "ugly mug" as he used to call it, appears at right. Probably Lismer named the Group. "Group of 7" he wrote on his drawing.

trails."[10] The drawings Lismer sketched in March 1920, the night the Group was christened at Harris's home (63 Queen's Park in Toronto) show Harris's energy.[11] Still young (thirty-five), insouciantly smoking a cigarette, completely at ease, Harris

sprawled on the wicker armchair in his living room, in contrast to Johnston who sedately crossed his legs. Another friend of Harris's, Fred Housser, the financial editor of the *Toronto Star* and the group's promoter (his 1926 book on the Group set the panegyric tone of later studies), described the impact of Harris's personality. He had the "same invigorating effect on the constitution as the nip of the season's first cold snap," said Housser.[12] No wonder Harris became the Group's "moving spirit" and "genius," as Albert Robson said.[13] (He was sympathetic to the Group, because he had employed many of them in the commercial art firm of Grip Ltd.)

Newton Mactavish, one of the early historians of Canadian art, called Harris "pivotal."[14] "Charismatic" is what this handsome man with the small natty moustache, who dressed with casual elegance, would be called today. He was also modest. In his own account, he denies his leadership.

The Group's name probably came from Lismer. He apparently mentioned it to Harris, perhaps the night in March he wrote it on one of his drawings.[15] Lismer would have had ample opportunity to learn about the American group, The Eight or the Ashcan School, since he had recently worked in Halifax, the home of Ernest Lawson, who was a member of this rebel movement. Harris admired Lawson's work too. Lawson's paintings had been on view in Toronto from 1912 to 1915 in exhibitions of the Canadian Art Club, and Harris had reviewed them in 1913. He would therefore have seen the logic of Lismer's suggestion. The Eight led to the Canadian Seven.

There were certain parallels between the two groups. Like the American group, and for that matter, the Canadian Art Club, the Group of Seven's central concern was exhibition.[16] Lismer's notes on his drawing of Johnston, made the night the name was decided on, are proof that an exhibition had been planned, probably the one held two months later at the Art Museum of Toronto.

"Group of 10 sketches each man" and "about 70 canvases for large room," Lismer noted on his sketch. The large, tunnel-ceilinged room which held the seventy paintings still exists at the Art Gallery of Ontario.

Exhibiting as a group created more of a statement than the earlier, separate showings at various societies like the OSA and the Royal Canadian Academy (RCA). "The whole group selects," Lismer wrote on his sketch. He meant all members of the Group of Seven would choose the works for the show. Perhaps they were angry at the jury system used by the societies.

As a unit for self-defence and a protective alliance, the Group set a style in Canadian art. Much later, Painters Eleven would have the same orientation towards exhibition. For the Group it meant forty shows over ten years, not only yearly ones in Toronto, but also many in the United States.

The Group was strategically located in Toronto. Harris (aided by Jackson) knew the right people to contact: the Harris family was socially prominent. As a result, acceptance was not long in coming. Despite the members' feeling that some critics detested them, by 1936, in a retrospective at the National Gallery of Canada, the Group became part of the canon of Canadian art. Successive retrospectives of individual members' work began in the late 1940s and continued at a strong pace for a decade and even until the 1970s. These shows pushed individual members towards sainthood. Some (one thinks of Thomson and Harris) achieved near godlike status.

At the same time, their achievement was transformed into an institutional one. Not only did many of them, especially Lismer and Jackson, teach generations of students, but all of them generously served on the innumerable committees of national institutions, particularly those of the National Gallery of Canada.

The work of the Group of Seven is found today in these public institutions, as though to underscore the time they gave so generously. As we study

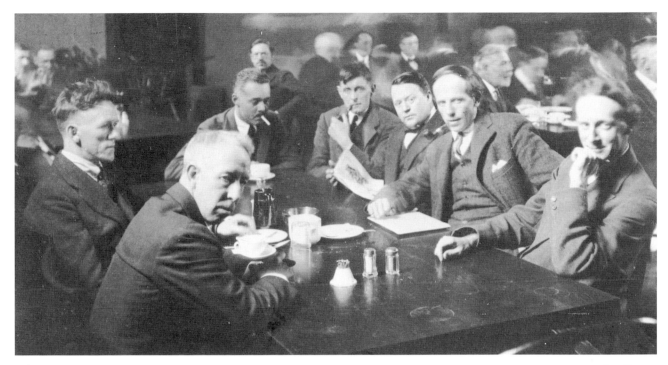

their paintings in the various collections, we may now find them less impressive than we hoped. Smaller than contemporary work, in the conservative medium of oil on canvas, and often sombrely coloured, they are sometimes boring and sometimes grandiloquent. Even their claim to be expressing Canada is at risk. The wild northland where many of these works were painted is today common vacation country. By contrast, too, to the crowds that stare at the works, the paintings of the Group seem pervaded with a profound, deathly calm. Harris's *Salem Bland*, for instance, an unforgettable portrait of a minister of the period, has a rock-like hardness. The minister has settled down for life in his chair.

The Group's way of painting can be impressively beautiful, of course, and the best of the work expresses the magic of painting: the trees that look like firecracker bursts of mustard against an intense blue sky in Lismer's *The Guide's Home, Algonquin Park* (1914, National Gallery of

The Group of Seven seated around a table at the Arts & Letters Club, Toronto, c. 1920
From left to right: Varley, Jackson, Harris, Barker Fairley (non-member), Johnston, Lismer, MacDonald.

This photograph catches the Group of Seven in a huddle at their favourite club (only Carmichael is missing). Harris is at the head of the table— understandably because of his leading role in the movement. At his left is Barker Fairley, a professor at the University of Toronto and later a painter. Fairley, they hoped in March 1920, might write the foreword to the catalogue of their first show, as Lismer noted on his drawing of Johnston the night the Group got its name. Behind Lismer is G. A. Reid, the Principal of the Ontario College of Art, with whom Lismer, the Vice-Principal, came into conflict during the years he taught there (1919-1927).

Canada); Harris's curious way of formalizing details, delineating a crack in a tree to recall an arrow or painting Pic Island to recall a curled-up cat; MacDonald's way of modelling the landscape in powerful building blocks or his exciting way of

13

handling colour abstractly in bold, red patches. These are the images that inspire. Nor was oil painting their only medium. Carmichael was a master of watercolour, which he revived and championed. Casson was an excellent water-colourist as well.

Of them all, Thomson was the most instinctive painter. His luscious use of thick pigment and his confident way of flicking on paint to represent trees in his small panels show us what's important about the Group. This heavy use of pigment has been called "painting with the penis" by contemporary women art dealers in contrast (they feel) to the dryer use of the medium by women artists. But Jackson also painted "dryly," so the idea is flawed. Still, it's worth playing with. The energy and vitality of these painters are reflected in their choice of imagery: waterfalls or rapids bursting free from the rocks that confine them. Here we may find an unconscious metaphor for exuberant male sexuality.

The members of the Group regarded themselves as rebels, and they were so regarded by the public of their day. They lived for experiment and associated it with a certain lack of finish compared to the work of Canada's nineteenth-century painters. Jackson specifically mentions experimenting with broken colour, dots and dashes, and under-painting.[17] Since many of them had learned sound academic practice, their technique was actually quite conservative. In nature, they might paint an oil sketch or two, which they combined with studies in pencil to develop a canvas back in the

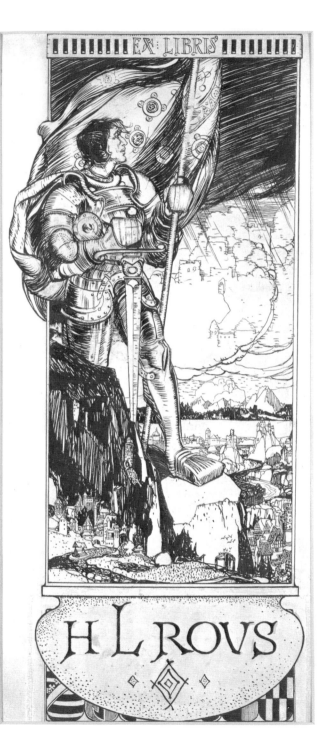

F. H. Varley
Ex Libris: H. L. Rous, c. 1913
Ink on card
35.5 × 16.5 cm
Agnes Etherington Art Centre, Queen's University, Kingston

The style they had to leave behind was an illustrative one they'd learned from commercial art, a pre-Raphaelite hangover, as in Varley's design for H. L. Rous's bookplate.

studio. Because of their training, whether academic or commercial art, all members of the Group were exquisite draftsmen. The illustrative style from commercial design, on the other hand, all pen-and-ink and Art Nouveau (as in Varley's bookplate for H. L. Rous) had to be left behind.

What was new in the Group's paintings was not so much their style but the sites they depicted. Other painters before the Group, like Lucius O'Brien and Frederick Arthur Verner, had wished to paint Canada. But the Group was alone in suggesting that what was Canadian lay in the landscape of northern Ontario and in considering art a matter of "taking to the road" and "risking all for the glory of a great adventure."[18] The members' idea of matching themselves against the forces of nature is linked to adventure novels of the day, like Stewart Edward White's *The Forest* (1903), a lyrical guide to the wonders and perils of camping in Lake Superior country. Its gruff tone would have found a ready acceptance in the hearts of Group members.

Since the time of the Barbizon school, nature had been a powerful symbol of freedom: "freedom from the city, from style, from convention, from constraint."[19] For the Group of Seven, the choice of site was a way of saving Canada from the machine and from materialistic values—values Harris may have found in his family and some of his acquaintances (the Massey-Harris Company sold farm machinery). As Housser said, the Group of Seven movement was about the only activity in Canada providing encouragement to those who "desire to see our people liberated from the hypnotic trance of a purely industrial and commercial ideal."[20] In this process, Nature was a path of escape. More important, it also became the passage through which God spoke to man. As one critic wrote of MacDonald, "Forms of nature to him were the expression of sublime laws and cosmic energy."[21]

The words written by MacDonald on Thomson's cairn in Algonquin Park, a monument erected after Thomson's death by drowning in Canoe Lake, reveal the same feeling about God and nature. Nature, said MacDonald, drew Thomson apart and "revealed itself wonderfully to him. It sent him out from the woods only to show these revelations and it took him to itself at last."

The Group as a whole stressed a less intellectual approach. Nature was a way of entering into the external reality that was Canada. They were "painting the Canadian Scene in its own terms," they believed, as Harris said of Lismer. They believed "Canada dictated the subject, the way of seeing, the technique and expression."[22] Voyages were their pathways to discovery, a way of mapping the country they loved.

In this adventure, the search for motifs, the Group is at its most attractive. Each man's story is the same as that of any pleinairist, like Monet's, for instance; "first, the search for *motifs*, then an explosion of activity with many starts, followed by fury and frustration at the fickleness of the weather...."[23] One thinks of Thomson painting in a storm, "at one with the storm's fury," as Harris said, or the way all of them waited for the weather to clear in Algoma.[24] Thomson in particular considered himself an archivist of the seasons in Algonquin Park and dashed from one place to another to record the changes in colours. In a curious, gentle way, he joked with ranger Mark Robinson, who lived on Canoe Lake, by asking him repeatedly while pacing the floor, "Where do I get it?" By "it," Thomson meant the motif he wanted, like an old pine tree. "I want to get a pine with old branches coming out low down and large branches, the ugliest looking old thing you know of, and bark on some of it... a dead pine is preferred," he told Robinson once. On another occasion, Thomson asked Robinson where he could find some black spruce with ragged tops. "I don't want all this here nice tops like the white spruce has. I want the ugliest looking old black spruce you can find to go agin that sky."[25]

Thomson's sincerity cannot be doubted. His quest was closer than any other Canadian

painter's to Monet's, to record the weather in a way that recalled an explorer. "Bushwhacker" and "prospector" are words Housser used to describe the Group, descriptions of their joint fantasy. As Housser said:

> This task demands a new type of artist; one who divests himself of the velvet coat and flowing tie of his caste, puts on the outfit of the bushwhacker and prospector; closes with his environment; paddles, portages and makes camp; sleeps in the out-of-doors under the stars; climbs mountains with his sketch box on his back. Possibly never before have such physical demands been made upon the artist, nor have painters been faced with so quantitudinous a mass of new material; such complexity of rhythm and design; such elemental entities in forms, the virgin mood unchastened by contrast with man.[26]

There was more than a touch of performance, as with all the Group, in Thomson's stance. Unconsciously, he and the other members chose a myth already sympathetic to Canada, that of the no-nonsense, independent, rugged pioneer. For them, quite consciously, the myth provided a methodology with which they worked, but it was more a declaration of bias than a statement of literal fact. It is easy to exaggerate their woodcraft. Thomson and Jackson were excellent woodsmen; but MacDonald "was a quiet, unadventurous person, who could not swim, or paddle, or swing an axe, or find his way in the bush," as Jackson said.[27] Nevertheless, MacDonald, though slight in build, was the one most imbued with the grandeur of the new imagery. His paintings of Algoma with their evocative sense of panorama can never be equalled.

The voyage of discovery led the Group away from Toronto to Muskoka, Georgian Bay, and Algonquin Park, then further north to Algoma and Lake Superior, and finally to the Rockies. Without realizing it, they remained regionalists, favouring

J. E. H. MacDonald, c. 1930 (?)
Art Gallery of Ontario, Toronto

J. E. H. MacDonald with his red hair, florid complexion, and twinkly blue-grey eyes ("half quizzical, half coldly candid," as his friend, Albert Robson said) had a deft wit and unique charm.

Ontario and Quebec, although Jackson explored the entire country for the members later, from the west to the Arctic. In an extraordinary fulfilment of the panorama they painted, Jackson's trails crossed and recrossed Canada "like the pattern of ski tracks on the fresh snow of a winter hillside," as Lismer said.[28] Jackson played out the explorer's pattern set long before in Algonquin Park by Tom Thomson.

In the Group's exploration of nature, man is placed in conflict with it. Nature was the "measure of man's stature," as Lismer said, and the Group's favourite motif of a pine silhouetted against the sky dramatically symbolized man in his battle with

the elements. A struggle in which man triumphed was the story of their painting, the Group felt. The group members repeatedly painted the lumber drive, for instance. Somewhere in their minds, they saw themselves as lumberjacks. As Mac-Donald said in a newspaper article defending the Group, "It is evident that a drive of some kind is on."[29] Descriptions of the drive, like Stewart Edward White's, help us understand the heroic way in which Group members regarded themselves. The scene was composed of the raging, untamed river, the fierce rush of the logs, and what White described as "the cool little human beings poised with a certain contemptuous preciosity on the edge of destruction...." They felt like men who, a dozen times an hour, faced death "with a smile or a curse."[30]

Like the log drive subject they loved, the waterfall was a subject of early work. There were other images, like railway trains, that they enjoyed painting in the period between 1910 and 1920, which mirrored their concern with modern life. MacDonald painted a beautiful train subject, *Tracks and Traffic* (1912, Art Gallery of Ontario). During the same period Harris painted city folk in fashionable clothes walking along Toronto streets. But with the recognition of the north as the "perfect" painting site, mere reportage was submerged into a more contemplative sort of art, reveries about nature or about colour, as in Carmichael's *October Gold* or *The Glade* (both 1922).

The Group painted in a way that accorded with the myth of the movement, energetically, and most important, simply. For the Group, simplicity was more than a virtue: it was the key to success. Thomson and Harris might capture the minute details of the scene before them in their sketches. They then summarized what they had seen to create a grand design, capturing the "big spirit and a mood." Walt Whitman's words on simplicity in his preface to *Leaves of Grass* in 1855 were used as evidence in favour of their attitude. They believed, like Whitman, "The art of art, the glory of

expression is simplicity."[31] Jackson, for instance, in 1921, described sketching in Algoma:

> Out of a confusion of motives the vital one had to be determined upon. Sketching here demanded a quick decision in composition, a summarizing of much... detail, a searching-out of significant form, and a colour analysis that must never err on the side of timidity.[32]

Harris, in particular, had a designer's instinct for decisive arrangement. Study of works like his *Algoma Country* (1920-1921, Art Gallery of Ontario) reveals the simple way he attained his effect, using a number of tonal steps and a surprisingly simple but dramatic colour scheme. In his *Above Lake Superior* (c. 1922, Art Gallery of Ontario, p. 69), he courted the effect light has as it falls from the left, irradiating the tree trunks one by one.

Such careful design seems at first a student's way of working. But Harris understood that simplicity was the key to an easily grasped, complex composition. This aspect of painting—with its directness; stressing large, bold forms and movements; and simply recorded effects of light and colour—was an essential attribute of the Group of Seven's high style. It helped the public grasp sublime, visionary, and essentially innovative content. The desire for simplicity also led to a more mundane matter—the tendency of the Group to work in horizontal planes and formats. Vertical formats were anathema to them, as we can see from the plates in this book; among our few uprights are Varley's and Lismer's self-portraits.

The desire for simplicity accounted for different stages in Group work. The attachment to painting the real world came partly from the Group's mentors, the Impressionists. Their mentors' way of seeing, as Cézanne said of Monet, of being "just an eye," left an irreversible imprint on Group thought. But into this perceptual world Harris introduced a new spiritualism, based on

the transcendentalists and theosophists, in which the North became, as he said, a "transmuting agency," shaping the Group, he hoped, into its own "expressiveness."[33] The heady mood set by Harris spread to the others. By the time they travelled to Lake Superior in the early 1920s, "light as a spiritual quality is introduced. There is a settling in, a restraint, a different application of paint, an evener rhythm, and a more careful moulding of forms."[34] (Housser is speaking of Harris's work, but the change is found in the others', too.) By 1924 the Group's style had solidified. In their decade of work together, going to Lake Superior was the turning point.

Perhaps they would have developed a more symbolic format even without the example of the exciting work Harris painted there. From an early date, Jackson had known of Cézanne's dictum that "art runs parallel to Nature and has laws of its own." A trip to the Rockies in 1924, he recalls, led him to recognize the singular application of the words.[35] The date is significantly close to that of the Lake Superior trips. Lake Superior and the way Harris painted it, as a "country of the soul" with shafts of light breaking through the clouds to illuminate the surface of the water, helped them all "see the light."[36] From then on, simplification led, in ever-increasing giant-steps, toward abstraction for two of them; Harris and (for a single moment) Carmichael. Harris did not stay in any established position for long. By 1936, at the time of the retrospective which codified the position of the Group, he had decided permanently on "the other route" and become an abstract painter for the rest of his life.

There are certain virtues to be gained from painting images true to Nature. The painter never lacks variety, and he can truly discover what he sees. Today, we note with amusement, France looks in places like so many Impressionist paintings. In the same way, certain places in Canada bear an uncanny resemblance to the paintings of the Group of Seven. In a sense the Group re-invented Canada.

But a devotion to the pantheism of lake, forest, and mountain has its limits. The Group of Seven never lost control over what they saw; they did not, or could not, recognize the strength that comes from using the unconscious. Finding the motif was half their battle; recording it the other half. If, as Lismer said, an artist's greatness lies in his ability "to give us pictures of our own inarticulate selves, to widen the horizons of our unexpressed thoughts and hopes...," then the Group failed us.[37] They offered us only an empiricist's view. Still, painters among them like MacDonald recognized the strengthening power of the imagination. He even illustrated a quotation from W. B. Yeats's dramatic poem The Shadowy Waters.[38] "All would be well/Could we but give us wholly to the dreams/... for it is dreams/That lift us to the flowing, changing world/That the heart longs for," the passage runs. MacDonald, and probably the others, especially at the end of their decade of work together, may have doubted the role of nature alone.

On the other hand, their love of the real world was genuine, never-ending, and one of their strengths. They underscored it by quoting from their favourite poet Walt Whitman, whose songs of the open road embodied the American dream. Housser said at one point that Harris had in him a streak of Whitman, along with a streak of Heinrich Heine, one of Germany's most discursive, witty poets. The two did "not blend," Housser believed.[39] There were other favourite writers—for MacDonald, Henry David Thoreau, Tolstoy, Robert Burns, and landscape poets like Wordsworth.[40] Harris preferred philosophers like William James and Emerson, whose work he'd read in his youth.[41] Jackson had slogged through art books, among them Ruskin's Modern Painters, he recalled. MacDonald subscribed to the important Munich periodical, Jugend.[42] (Some of the Art Nouveau style in their early work may have come

from there.) Poetry and novels and international periodicals helped disperse the Group's persistent feeling of loneliness.

The discovery that painters in other countries were working in a similar way also alleviated their sense of isolation. Harris and MacDonald studied contemporary Scandinavian art at an exhibition at the Albright Art Gallery in Buffalo in 1913; some of the works in this big survey, particularly of Swedish painter Gustaf Fjaestad, seem to have had some relevance for them.[43] Harris and Varley admired the work of the Russian painter Nicholas Roerich.[44] When the American painter, illustrator, and writer Rockwell Kent came to Toronto on a lecture tour in 1934, he took it by storm, less through his paintings than through his exciting presentation. (Kent had long been a favourite author; Jackson never travelled on sketching trips without Kent's *Wilderness, A Journal of Quiet Adventure in Alaska*, published in 1920.)[45] Occasionally, too, critics noticed the influence of Oriental art, as in the Group of Seven paintings shown at Wembley in England in 1924.[46] Housser noted the similarity of Lismer's running waves to Japanese painters'. Invariably, such comparisons seem blown out of proportion. Influences did not suit the Group's stance as explorers. Too slavish an adherence to another style, one feels, would have been regarded by them as a sign of failure.

Study of the work of individual members bears more interesting results. "We continually derived inspiration and encouragement from each other," Harris says.[47] The first painting pioneers among the Group were MacDonald, who influenced all with his powerful, shaping imagination; Thomson, the painter-poet, who intuitively understood the quality of paint; and Harris, the great formalist.

Today, some work by members of the Group looks better than ever before. Gentle, paternal A. Y. Jackson looks at his worst in a retrospective (the National Gallery of Canada, 1982-83), and at his best when his paintings are hung with inter-

Franklin Carmichael, Antwerp, c. 1915
Private collection, Toronto

Lismer and Varley told Carmichael to go the Académie des Beaux Arts in Antwerp to study, as they had done years before.

national work of the same period (the Art Gallery of Ontario's *Mystic North* exhibition, 1984.) Then, his unusual compositions, odd in their choice of point of view, his flat, tapestry-like, sumptuously painted surfaces, and his ruddy colours, stand up more than well.

The work of J. E. H. MacDonald also looks better as the years pass. His palette was dark, tough, and rich, like Jackson's, but his colouring more fiery and his style more elegant. His sense of composition is more oriented towards his meditation on design, a subject in which he was a master. (MacDonald was the great calligrapher of the period and a designer of consequence.)

Arthur Lismer, c. 1926
Art Gallery of Ontario, Toronto

Lismer, with his long and streaky hair, "wisps hanging all around as if he had been blown by the wind" as one student described him, was beloved by Group members and students alike. Born in Sheffield, England, like Varley whom he encouraged to come to Canada, he looked English.

F. H. Varley
J. W. G. (Jock) Macdonald, 1930
Oil on canvas
50.7 × 45.9 cm
Winnipeg Art Gallery

The Group influenced three generations of Canadian art: their own, the Canadian Group of Painters formed in 1933 and Painters Eleven formed in 1953, of which Jock Macdonald was a member. Varley met Macdonald in 1926 in Vancouver. They became close friends. Varley's portrait shows some of Macdonald's personal characteristics—his tousled hair, for instance—but is less a portrait of the man than a measure of the broadly modernist style Varley had developed.

The prettiness of Carmichael's work is saved by his attention to bizarre weather conditions: curtains of light lift in the corners of his clouds to reveal distant storms or clearing skies. His watercolours are more successful than his paintings—he was one of the great water-colourists of Canadian art. But even in this medium, his work could be mechanical. Still his clouds are not flat. They have a front, side, and top, as he made graphically clear.

For Arthur Lismer, the high style of the Group of Seven was not always congenial. Many of his larger paintings lack conviction. His charm and wit surfaced in the drawing medium—he left behind acres of gay sketches which cartooned friends and foes alike. His energy is expressed in all his work. "He had more vitality than any of them," says his student and friend, Charles Gold-hamer.[48]

Harris, a product of Upper Canada College,

was on the one hand more polished, but also more distant, reserved, and shy. On the other hand, he was capable of the greatest vulgarity in his work. From his study of theosophy he believed in expressing sexuality in symbolic terms, and in his Lake Superior and Rockies subjects, the use of such semi-symbolic sexual imagery (penal mountains and vaginal clouds) seems too overt. Although the capacity to be coarse was part of his character, so was steadfastness. Within the group, he was the most orderly—a quality reflected in the development of his paintings. He always worked parallel to the canvas as though a diagonal might rattle him. Frederick Horsman Varley was his opposite. The most talented draftsman of the Group and one of the most spontaneous, he was in some ways closer to Thomson or to Johnston, whose work is more oriented toward the atmospheric painters of turn-of-the-century Canada. Varley loved diagonals.

There were three other members of the original Group: A. J. Casson, Carmichael's assistant at the commercial art firm of Rous & Mann, whose

Frank H. Johnston
Greeting card, c. 1921-23
Handcoloured woodcut on paper
5.4 × 10.4 cm
Winnipeg Art Gallery

Johnston showed with the Group only during its first exhibit. Then he moved to Winnipeg to become principal of the art school. Christmas cards like this show he still thought of friends in the East.

Left: Lawren Harris and Isabel McLaughlin on a picnic in British Columbia, 1930s

Harris's influence on the younger generation was partly caused by friendship, as we can see in this photograph of the older painter with one of the important woman painters of the next generation.

Below from left to right: A. J. Casson, Lawren Harris, F. H. Varley, A. Y. Jackson, and Arthur Lismer, at the opening of Lawren Harris's exhibition of October 15-November 14, 1948.
Art Gallery of Ontario, Toronto

By 1948, the Group had grown old but the members were still full of fun. Harris and Jackson have propped Varley up (he had had too much to drink.) The action of Harris and Jackson suggests their role in the Group, that of unofficial leaders.

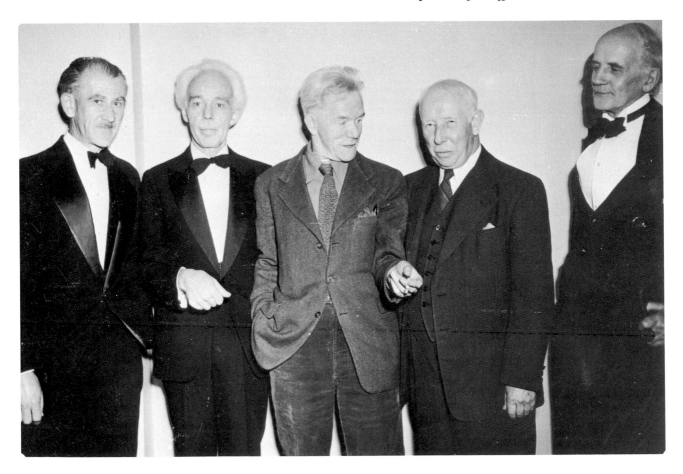

lucid way of working found its happiest fulfilment in the tranquil watercolours of Ontario's towns and villages; Edwin Holgate, a gifted designer and craftsman, who contributed to the movement its only paintings of nudes; and Lionel LeMoine FitzGerald, whose membership in the early 1930s was a tribute to his work's sensitivity and restraint.

The work of these ten painters has survived and, in some respects, grown better with time. "Up to the present we have not created much that will hold posterity spellbound," said Jackson, ever-modest—and he was right.[49] The Group does not hold us spellbound. But the impact of their work, their existence, puts us, as it did Emily Carr so long ago, on our mettle. From the Group we gain inspiration about our own country. For those who have not yet realized the significance of the Group, the last line of Walt Whitman's *Song of Myself* should suffice. "I stop somewhere waiting for you," Whitman said. In the same way, for those who haven't yet discovered it, the Group of Seven is waiting just around the corner.

A. Y. Jackson, 1950
Art Gallery of Ontario, Toronto

Some of Jackson's most impressive work came from painting scenes such as this, a vista from the Teshierpi Mountains.

Notes

1. Emily Carr, *Hundreds and Thousands: The Journals of Emily Carr* (Toronto and Vancouver: Clarke Irwin, 1966), p. 6.
2. Conversation with Gordon Rayner, February 29, 1984.
3. Conversation with Graham Coughtry, January 25, 1984.
4. Katharine McTavish, "Rae Johnson: Pleasure," *C Magazine* 1 (Winter 83/84), 55.
5. Anne Savage, quoted in Peter Mellen, *The Group of Seven* (Toronto: McClelland and Stewart, 1970), p. 186.
6. F. B. Housser, *A Canadian Art Movement* (Toronto: Macmillan, 1926), pp. 60-61.
7. *Ibid.*, p. 40.
8. G. P. de T. Glazebrook, *The Story of Toronto* (Toronto: University of Toronto Press, 1971), p. 211.
9. Housser, *A Canadian Art Movement*, p. 136.
10. A. Y. Jackson, *A Painter's Country; the Autobiography of A. Y. Jackson* (Toronto: Clarke Irwin, 1958), p. 115.
11. The drawings by Lismer are in the Art Gallery of Ontario Library archives. Peggie Knox, Harris's daughter, identified the wicker chair as part of the furniture of Harris's home, March 24, 1984.
12. Housser, *A Canadian Art Movement*, p. 85.
13. Albert H. Robson, *Canadian Landscape Painters* (Toronto: Ryerson, 1932), p. 152.
14. Newton MacTavish, *The Fine Arts in Canada* (Toronto: Macmillan, 1925), p. 154.
15. Lois Darroch, *Bright Land* (Toronto and Vancouver: Merritt, 1981), pp. 56-58. Lawren P. Harris, Harris's son, who was ten at the time, believes the name came from a critic, possibly Augustus Bridle (conversation, March 23, 1984). O. J. Firestone, *The Other A. Y. Jackson* (Toronto: McClelland and Stewart, 1979), p. 137, suggests the name was given by the press after the first exhibition but also recognizes Lismer's role, p. 222, n. 228.

16. Housser, *A Canadian Art Movement*, p. 147.
17. A. Y. Jackson, "The Origin of the Group of Seven," *High Flight* (Vancouver, Toronto, and Montreal: Copp Clark, 1951), p. 162.
18. "Foreword," *Group of 7 Exhibition of Paintings* (Toronto: Art Gallery of Toronto, 1922), n.p.
19. Robert Gordon and Andrew Forge, *Monet* (New York: Harry N. Abrams, 1983), p. 21.
20. Housser, *A Canadian Art Movement*, p. 156.
21. Augustus Bridle, *The Story of the Club* (Toronto: Arts & Letters Club, 1945), p. 60.
22. Lawren Harris, "Arthur Lismer," *Arthur Lismer Paintings 1913-1949* (catalogue) (Toronto: Art Gallery of Toronto, 1950), p. 9.
23. Gordon and Forge, *Monet*, p. 9.
24. Lawren Harris, *The Story of the Group of Seven* (Toronto: Rous & Mann, 1964), p. 19. Reprinted here, p. 26.
25. "Alex Edmison Interviews Mark Robinson," tape recording made at Canoe Lake, 1952 (October 1956, first carbon), pp. 4-5.
26. Housser, *A Canadian Art Movement*, p. 15.
27. Jackson, *A Painter's Country*, p. 45.
28. A. Lismer, "A. Y. Jackson," *A. Y. Jackson Paintings 1902-1953* (catalogue) (Toronto: The Art Gallery of Toronto, 1953), p. 7.
29. J. E. H. MacDonald, "Bouquets from a Tangled Garden," *Toronto Globe*, March 27, 1916.
30. Stewart Edward White, *The Forest* (New York: The Outlook Company, 1903), p. 94.
31. Housser, *A Canadian Art Movement*, p. 148.
32. A. Y. Jackson, "Sketching in Algoma," *The Canadian Forum* 1 (March 1921), pp. 174-175.
33. Harris, *The Story of the Group of Seven*, p. 11.
34. Housser, *A Canadian Art Movement*, p. 187.
35. A. Y. Jackson, "Artists in the Mountains," *The Canadian Forum* 5 (January 1925), 112-114.
36. Housser, *A Canadian Art Movement*, p. 187.
37. Arthur Lismer, "Art Appreciation," *Yearbook of the Arts in Canada* (Toronto: Macmillan, 1929), p. 59.
38. Bridle, *The Story of the Club*, p. 78.
39. Housser, *A Canadian Art Movement*, p. 122.
40. Thoreau MacDonald, "Introduction," in E. R. Hunter, *J. E. H. MacDonald* (Toronto: Ryerson, 1937), p. 4; Robson, *Canadian Landscape Painters*, p. 137.
41. Letter from Bess Harris to J. Russell Harper (1962), reproduced in Joan Murray and Robert Fulford, *Lawren S. Harris: The Beginning of Vision* (Vancouver: Douglas & McIntyre, 1982), p. 213.
42. Jackson, *A Painter's Country*, p. 4; Nancy Robertson [Dillow], *J. E. H. MacDonald, RCA, 1873-1932* (catalogue) (Toronto: Art Gallery of Toronto, 1965), p. 9.
43. For a discussion of the influence of Scandinavian art on the Group, see Ronald Nasgaard, *The Mystic North* (Toronto: University of Toronto Press, 1984). Jackson, *A Painter's Country*, p. 158, mentions Harris and Roerich. For Varley's admiration of Roerich, see C. Varley, *F. H. Varley* (exhibition catalogue) (Edmonton: Edmonton Art Gallery, 1981), p. 184, n. 131.
44. Jackson, *A Painter's Country*, p. 158.
45. *Ibid.*, p. 132.
46. Housser, *A Canadian Art Movement*, p. 177.
47. Harris, *The Story of the Group of Seven*, p. 18.
48. Interview with Charles Goldhamer, January 17, 1984.
49. Jackson, *A Painter's Country*, pp. 161-162.

The Story of the Group of Seven
Lawren Harris

This account is drawn from Lawren Harris, *The Story of the Group of Seven* (Toronto: Rous & Mann Press Limited, 1964).

I look upon the Group of Seven as a movement in art in Canada, and not in any sense as an organization. Accordingly, I have, in my story of the Group, included Tom Thomson as a working member, although the name of the Group did not originate until after his death. Tom Thomson was, nevertheless, as vital to the movement, as much a part of its formation and development, as any other member.

In order that you may be able better to understand the formation of the Group of Seven, its activity and development, I feel I should give you a brief personal account of events as I remember them.

A group of artists working in a commercial art firm devoted their week-ends and holidays to sketching in the country near Toronto. Four of these artists became members of the Group of Seven. They were J. E. H. MacDonald, Arthur Lismer, Frank Johnston, and F. H. Varley. Frank Carmichael was also a member. A. J. Casson joined the Group. Tom Thomson was part of the movement before we pinned a label on it.

I first met MacDonald at the old Arts and Letters Club in Toronto fifty years or more ago. There was an exhibition of his sketches on the walls of the club; sketches of scenes painted in the vicinity of his home which was on the outskirts of the city. These sketches contained intimations of something new in painting in Canada, an indefinable spirit which seemed to express the country more clearly than any painting I had yet seen. I was deeply moved. Here, it seemed to me, was the beginning of what I myself vaguely felt; what I was groping toward—Canada painted in her own spirit. These sketches of MacDonald's affected me more than any painting I had ever seen in Europe. MacDonald and I became close friends.

The two of us discussed the possibility of an art expression which should embody the moods and character and spirit of the country. We learned that there was an exhibition of modern Scandinavian paintings at the Albright Art Gallery in Buffalo, and decided we should go there to see it. This turned out to be one of the most stimulating and rewarding experiences either of us had had. Here were a large number of paintings which gave body to our rather nebulous ideas. Here were paintings of northern lands created in the spirit of those lands. Here was a landscape as seen through the eyes, felt in the hearts, and understood by the minds of people who knew and loved it. Here was an art, bold, vigorous and uncompromising, embodying direct experience of the great North.

As a result of this experience in Buffalo, our enthusiasm increased. Our purpose became clarified, and our conviction reinforced. From that time on we knew that we were at the beginning of an all-engrossing adventure. That adventure, as it turned out, was to include the exploration of the whole country for its expressive and creative possibilities in painting. We first went to the Halibur-

ton country, then to the upper Ottawa River and the Laurentians north of Montreal, coming in contact for the first time with the indefinable spirit of the North.

In 1910, at an exhibition of the Ontario Society of Artists, we saw a painting entitled, *The Edge of the Maple Wood*. It stood out from all the other paintings as an authentic, new expression. It was clear, fresh, and full of light, luminous with the sunlight of early Canadian spring. If any of you were to see it today you might find it quite serene. Nevertheless, that painting is significant because it marked the first time that any Canadian painting had contained such startling verity.

This painting was the work of A. Y. Jackson, a Montreal artist. None of us in Toronto had heard of him before. At once I wrote to Jackson a long screed full of enthusiasm, enlarging on the possibilities of painting the Canadian scene as no one yet had painted it except himself in *The Edge of the Maple Wood*. Jackson replied to my letter with an enthusiasm equal to my own. In it he told me that he was going to Berlin, Ontario (now called Kitchener), to visit an aunt, and asked me if I would go there and have a talk with him. I did so. I told him that we had plans for a studio building in Toronto, the first of its kind in Canada, and invited him to join us and occupy one of the studios.

Before Jackson came to Toronto we carried on a lively correspondence. I quote from one of his letters:

> Yes, I am quite in accord with you. You have only to look over the catalogues of our exhibitions and you see trails crawling all over Europe, *Spring in Belgium, Summer in Versailles, Autumn in the Riviera*. Ye gods, imagine Monet pottering around Jamaica, Pissaro hard at it in Japan, Renoir out in the Rockies, Sisley in Sicily—and the French Impressionists would never have existed.

The Studio Building was completed in 1914. MacDonald, Jackson, and I had studios in it. We tried to induce Tom Thomson to join us. Thomson loved the north. The north country and painting were his life. He lived through the winter in town with the sole idea of making enough money so that he could go north as soon as the ice broke in the rivers and lakes. Tom did not want a studio in the building. He would not feel at home in it. There was a dilapidated old shack on the back of the property which was built in the days when that part of Toronto was the town of Yorkville. We fixed it up, put down a new floor, made the roof watertight, built in a studio window, put in a stove and electric light. Tom made himself a bunk, shelves, a table, and an easel, and lived in that place as he would in a cabin in the north. It became Tom's shack, and was his home until he died in 1917. It has been known as "Tom's shack" ever since.

We had commenced our great adventure. We lived in a continuous blaze of enthusiasm. We were at times very serious and concerned, at other times, hilarious and carefree. Above all, we loved this country, and loved exploring and painting it. Emerson once wrote, "Every great and commanding movement in the annals of the world is the triumph of enthusiasm." Please do not think that we had any idea of leading a great and commanding movement; but we did have enthusiasm. We began to range the country and each one of us painted hundreds of sketches. The love of the country and our irrepressible ardour commenced to infuse something new into our work.

Thomson began to develop. His work commenced to emerge into the clear Canadian daylight. His painting had been tight and sombre, almost a grey monotone in colour. Jackson's sparkling, vibrant, rich colour opened his eyes, as it did the eyes of the rest of us, and Tom saw the Canadian landscape as he had never seen it before. It amounted to a revelation. From then on nothing could hold him.

I should explain that there were, at this time, no exhibitions of modern painting in Canada. No exhibitions came from Europe, save occasional

shows of third-rate old masters and various kinds of dealers' wares, and nothing at all came from the United States. Thus, in everything to do with art, we were entirely dependent on ourselves. We had to generate within ourselves everything which made for the development of our work. So we continuously derived inspiration and encouragement from one another.

Thomson knew the north country as none of us did, and he made us partners in his devotion to it. His last summer saw him produce his finest work. He was just moving into the full tide of his power when he was lost to us. Tom was an adept woodsman and canoeman. He was at the same time sensitive and given to occasional fits of despondency. He would often sit in the twilight, leaning over from his chair, facing his painting, after working at high pitch all day, and flick bits of wooden matches on the thick wet paint where they stuck. He had a poor opinion of his own work, but an exaggeratedly good opinion of the work of the rest of us. Because of his lovable nature and unusual character, he attracted visitors, and we had perforce to protect him from them; for if they expressed admiration for one of his sketches, Tom would immediately give it away. We appreciated the value of Tom's work even if he did not. Tom was tall, lithe, and very graceful. He was also a real craftsman. He made trolls for fishing out of piano wire; sometimes he made beads and hammered out pieces of metal which were works of art in themselves.

Dr. James MacCallum was a partner in the Studio Building venture. He too was an expert woodsman and canoeman and a man of the north in his summer holidays. Not only did he share our enthusiasm; he contributed something to it. Over a period of years he invited Jackson, MacDonald, Lismer and Varley to his summer home near Go-Home Bay, on Georgian Bay, to paint. Dr. Mac-Callum helped support Thomson by buying his sketches and paintings, and ended up owning the largest collection of Thomson's work in the coun-try. He died years ago, and left his collection to the National Gallery of Canada.

When he was in Toronto, Tom rarely left the shack in the daytime, and then only when it was absolutely necessary. He took his exercise at night. He would put on his snowshoes and tramp the length of the Rosedale ravine and out into the country, and return before dawn. In the north, on fine nights, he would sleep in the bottom of his canoe. He would push it out into whatever lake he was on, crawl under the thwarts, roll himself in his blanket, and go to sleep.

I remember one afternoon in early spring on the shore of one of the Cauchon lakes in Algonquin Park when a dramatic thunderstorm came up. There was a wild rush of wind across the lake and all nature was tossed into a turmoil. Tom and I were in an abandoned lumber shack. When the storm broke, Tom looked out, grabbed his sketch box, ran out into the gale, squatted behind a big stump and commenced to paint in a fury. He was one with the storm's fury, save that his activity, while keyed to a high pitch, was nonetheless controlled. In twenty minutes, Tom had caught in living paint the power and drama of storms in the north. Here was symbolized, it came to me, the function of the artist in life: he must accept in deep singleness of purpose the manifestations of life in man and in great nature, and transform these into controlled, ordered and vital expressions of meaning.

The war of 1914-18 dispersed us. MacDonald, Lismer, Varley and Johnston were too much occupied to give much time to painting. Jackson was wounded in France. During the third year of the war I was discharged from the army as medically unfit, and devoted over a year to regaining my health. Dr. MacCallum and I went on an exploration trip to Manitoulin Island in northern Lake Huron, but finding it offered little for the painter, we went to Sault Ste. Marie and from there up the ramshackle Algoma Central Railway to a lumber camp at Mile 129. We found Algoma a rugged, wild

land packed with an amazing variety of subjects. It was a veritable paradise for the creative adventures in paint in the Canadian north.

After the war, for four successive years for a month in the autumn, we explored and painted Algoma. The Algoma Central converted an old box-car into suitable living quarters, put in a few windows, four bunks, a stove, water tank, sink, cupboard, two benches, and a table. We carried a one-man handcar inside for use up and down the tracks—two of us could manage to ride on it—and a canoe for use on the lakes and rivers. A freight train would haul us up the line, and leave the box-car on a siding at Batchewana or in the Algoma Canyon for a week or ten days. Then, on instructions, another freight would pick us up and haul us to another siding.

We worked from early morning until dark, in sun, grey weather, or rain. In the evening by lamp or candlelight each showed the others his day's work. This was a time for criticism, encouragement, and discussion, for accounts of our discoveries about painting, for our thoughts about the character of the country, and our descriptions of effects in nature which differed in each section of the country. We found, for instance, that there was a wild richness and clarity of colour in the Algoma woods which made the colour in southern Ontario seem grey and subdued. We found that there were cloud formations and rhythms peculiar to different parts of the country and to different seasons of the year. We found that, at times, there were skies over the great Lake Superior which, in their singing expansiveness and sublimity, existed nowhere else in Canada. We found that one lake would be friendly, another charming and fairy-like, the next one remote in spirit beyond anything we had known, and again the next one harsh and inimical. Later on, in the Rockies, we discovered that mountains vary markedly in character and mood. And we found that all these differences in character, mood, and spirit were vital to a creative expression in paint which went beyond mere decoration and respectability in art.

It was in Algoma that J. E. H. MacDonald did his best work. Such well-known paintings as *The Solemn Land, Mist Fantasy,* and *The Beaver Dam* resulted from these Algoma trips. One of the finest of Jackson's large canvases, entitled *Wartz Lake, Algoma,* also resulted from the Algoma experience, as did Arthur Lismer's *Isles of Spruce.* Both of these paintings now hang in the Hart House collection at the University of Toronto.

The last two seasons in Algoma we lived in log cabins; and, during the last few weeks of all, at Sand Lake further north where the country begins to flatten out. Lismer had to return to take up his work at the Ontario College of Art, and Jackson and I went on to the north shore of Lake Superior.

There, once again, we found new and inspiring subjects, both in the hills along the shores of the great lake and inland in the high country with its rugged scenery, rock streams, and innumerable lakes. In the autumn of each of the next four years we camped on or near the shores of Lake Superior from Heron Bay to Rossport, and usually remained there until the end of October. On one occasion we were frozen out, though we did learn to live quite comfortably in a tent at temperatures below freezing. Lismer came with us on one of these sketching trips, Frank Carmichael on two of them, and Casson on the last one.

During these years, Jackson spent a month or more toward the end of each winter in his beloved Quebec villages, La Malbaie, Baie St. Paul, Les Eboulements, St. Hilarion and St. Tite des Caps, or on the north shore of the Gulf of St. Lawrence. Others of us went into the northern Ontario woods in winter and, despite the fact that outdoor sketching was difficult at low temperatures, we managed to collect a fair amount of material.

After the Lake Superior trips, Jackson and I went to the Rocky Mountains, where we lived with the park rangers in their log cabins in Jasper Park. Sometimes we camped in order to sketch in more remote mountain country. We first spent ten days

with an iron-haired, taciturn ranger named Goodair, whose cabin was high up in the Tonquin valley. We became good friends and corresponded until he was killed by a grizzly bear one evening outside that same cabin. In September of the same summer we made a camp high up on the east side of Maligne Lake. We had spent a week there a month earlier and had then blazed a trail to this site. We started early in the morning to tote our bed rolls, small tent, sketching material, and food for ten days up to this spot. The going was tough, and so it was not until late that same evening that we were settled. We pitched the tent just above the timber line on sloping ground, there being no level location. I built up a pile of crossed sticks under the foot of my bed roll so that it was level. Jackson did not bother to do the same; he simply crawled into his bed roll and went to sleep. Next morning at sunrise I awoke and glanced over to where Jackson was when I last saw him. I looked out of the tent flap and there he was twenty feet below, pulled up against a rock, buried in his bed roll, still fast asleep.

After this expedition, and the Lake Superior painting trips, each one of us went to different parts of the country. Jackson continued to go to the Quebec villages, to Nova Scotia, and to Georgian Bay. Lismer went to the McGregor Bay country of Georgian Bay. Carmichael built himself a cabin by one of the lakes in the La Cloche mountains, and Casson went to the northern Ontario villages on his holidays. MacDonald spent a month of each summer at Lake O'Hara in the Rocky Mountains, and painted a large number of sketches there, from which he developed some outstanding canvases.

One summer, Jackson went on the Canadian Government expedition to the Arctic with Dr. Banting, who later became Sir Frederick Banting. Banting was infatuated with the Canadian north and became deeply concerned about its interpretation in art. Eventually he became a great admirer of the work of the Group. I say he became an

admirer, because when he first saw the paintings he was greatly puzzled. Like most other Canadians he had been conditioned by a way of seeing which was "foreign-begotten." But he was intrigued, visited us in our studios, and became so engrossed with the work of the Group that he took up painting himself, and accompanied Jackson on several sketching trips.

A few years after Jackson's and Banting's trip to the Arctic, Jackson and I joined the Government Arctic expedition. We were most fortunate on this occasion as this particular expedition made the most extensive trip ever taken in the Arctic region in one season. The ship went directly north to Godhaven on the Greenland coast, and then up the coast to Etah where Commander Peary used to winter, and then into Kane Basin. From this point we went south along the coast of Ellesmere Island into Lancaster Sound, where we were held up by ice for days. For four hours on our way out the ship was in danger of being crushed by the immense weight of the huge, moving ice-floes. We then went around the top of Baffin Island, down the east coast to Hudson Strait, through the strait and across the northern waters of Hudson Bay to Chesterfield Inlet. Later we returned through the strait, and proceeded southward along the Labrador coast to Nova Scotia.

While we were on this trip, Jackson and I painted a large number of sketches, although painting was difficult, as we usually saw the most exciting subjects while steaming through channels or while being bumped by pack ice. On many occasions we had time only to take rapid notes. These notes we worked up into sketches, crowded in our small cabin, seated on the edge of our respective bunks with only a port-hole to let in the light.

On all of our camping and sketching trips we learned to explore each region for those particular areas where form and character and spirit reached its summation. We became increasingly conscious of the fact that the spirit of the land must be dis-

covered through its own character if there is to be any real life in its art. We came to know that it is only through the deep and vital experience of its total environment that a people identified itself with its land, and gradually a deep and satisfying awareness develops. We were convinced that no virile people could remain subservient to, and dependent upon, the creations in art of other people in other times or places.

Through our own creative experience we came to know that the real tradition in art is not housed only in museums and art galleries and in great works of art; it is innate in us and can be galvanized into activity by the power of creative endeavour in our own day, and in our own country, by our own creative individuals in the arts. We also came to realize that we in Canada cannot truly understand the great cultures of the past and of other peoples until we ourselves commence our own creative life in the arts. Until we do so, we are looking at these from the outside. When, however, we begin to adjust and focus our own seeing through our own creative activity and conviction, we are working from the inside, with the creative spirit itself; then the arts of the past and of other peoples become immediate, alive, and luminous to us.

This way of working with the creative spirit in our own day and place is, of course, the same which has created all the great works of the past. It is the means by which a people finds its soul, and it creates the condition in which the soul may unfold. So it was that the creative life and work of the Group of Seven resulted from a love of the land. From the cities, towns, and countrysides to the far reaches of the northern ice-fields, it was an ever clearer and deeply moving experience of oneness with the spirit of the whole land. It was this spirit which dictated, guided, and instructed us how the land should be painted. To us there was also the strange brooding sense of Mother Nature fostering a new race and a new age.

Members of the Group of Seven

Franklin H. Carmichael, 1890-1945
Original member

A. J. Casson, 1898-1992
Member 1926

L. L. FitzGerald, 1890-1956
Member 1932

Lawren Harris, 1885-1970
Original member

Edwin Holgate, 1892-1977
Member 1931

A. Y. Jackson, 1882-1974
Original member

Frank H. (Franz) Johnston, 1888-1949
Original member; only showed with first exhibit

Arthur Lismer, 1885-1969
Original member

J. E. H. MacDonald, 1873-1932
Original member

Tom Thomson, 1877-1917
Died before Group was formed

F. H. Varley, 1881-1969
Original member

List of Illustrations

Frank Carmichael
The Glade, 64
October Gold, 65
The Upper Ottawa, Near Mattawa, 75
North Town, 83

A. J. Casson
Hillside Village, 84
Mill Houses, 86

Lionel LeMoine Fitzgerald
Pembina Valley, 72

Lawren Harris
Snow (II), 48
Elevator Court, Halifax, 62
Above Lake Superior, 69
From the North Shore, Lake Superior, 71
First Snow, North Shore of Lake Superior, 73
Lake Superior, Sketch II, 76
Grey Day in Town, 77
Pic Island, Lake Superior, 78
North Shore, Baffin Island, 88

Edwin Holgate
Nude in a Landscape, 87

A. Y. Jackson
Terre Sauvage, 39
March Storm, Georgian Bay, 55
Maple Woods, Algoma, 56
First Snow, Algoma, 59
Algoma Rocks, Autumn, 70
Barns, 81

Frank H. Johnston

Nature's Rug, Lake of the Woods, 63
Serenity, Lake of the Woods, 68

Arthur Lismer

A September Gale, Georgian Bay, 61
Isles of Spruce (pencil on paper), 66
Isles of Spruce (oil on panel), 66
Isles of Spruce (oil on canvas), 67
Islands of Spruce (pen and ink on paper), 67
In My Studio, 74

J. E. H. MacDonald

Lake Simcoe, 53
Falls, Montreal River, 54
Gleams on the Hills, 57
Mist Fantasy, Sand River, Algoma, 58
The Solemn Land, 60
Lake McArthur, Yoho Park, 79
Cathedral Peak, Lake O'Hara, 82
Northland Hilltop, 90
Georgian Bay, 91

Tom Thomson

In the Northland, 40
Autumn, Algonquin Park, 41
Autumn Foliage, 42
First Snow in Autumn, 43
Snow in October, 44
Bateaux, 45
The Birch Grove, Algonquin Park, 46
Autumn Birches, 47
The Jack Pine, 49
The West Wind, 50

F. H. Varley

The Sunken Road, 51
Self-Portrait, 52
Sphinx Glacier, Mt. Garibaldi, 85
Mountain Lake, 89
Lynn Valley, 92

THE BEST OF
THE GROUP OF SEVEN

A. Y. Jackson
Terre Sauvage, 1913
Oil on canvas
127 × 152.4 cm
National Gallery of Canada,
Ottawa

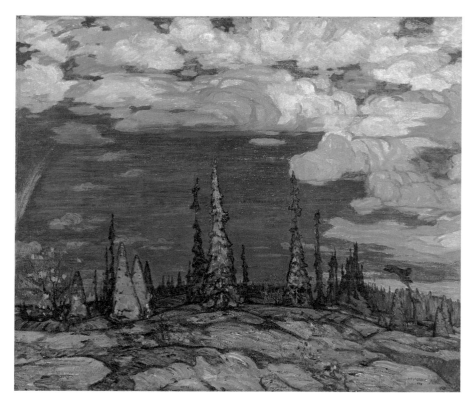

Jackson's *Terre Sauvage* (1913) was the first large canvas
announcement of the new style. The north country as subject matter,
broadly handled design, and boldly painted surfaces are leitmotifs of later
Group of Seven work. Jackson already had discovered his favourite way of
handling a view in parallel bands to the picture surface. The rainbow at
the left side of the painting suggests the high hopes of the fledgling group.
Jackson's own contribution is suggested in the bizarre shapes of the
trees—a curious but compelling detail.

Jackson painted *Terre Sauvage* from sketches he made while
canoeing around the islands and exploring the intricate channels and
bays of Georgian Bay, but the painting's high-and-dry appearance, like a
mountain peak after the Flood, led his friend MacDonald to call it Mount
Ararat.

Tom Thomson
In the Northland, c. 1915
Oil on canvas
101.5 × 114.8 cm
Montreal Museum of Fine Arts
Gift of friends of the Museum,
1923

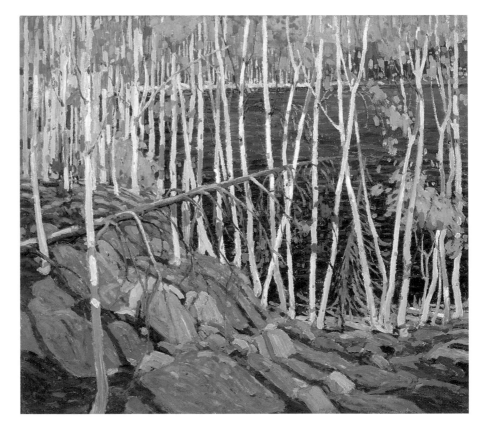

By the fall of 1915, Thomson's sketches had become more intense in their colouration; he also enjoyed using a vibrant black ground to set off the oranges and golds of the fall trees. In *In the Northland*, painted that winter, the blue water sets off the complex pattern of birch trees on the shore. The painting has an extraordinarily decorative quality; Thomson studiously avoided the allusion of depth. Perhaps he was thinking of simply creating a design with a general effect of relaxation and quiet. The sunny space of the painting seems to provide a tranquil, private shelter through which a viewer can look without being observed.

Tom Thomson
Autumn, Algonquin Park,
c. 1915
Oil on canvas
51.2 × 41 cm
McMichael Canadian
Collection, Kleinburg
Gift of C. F. Wood, 1975

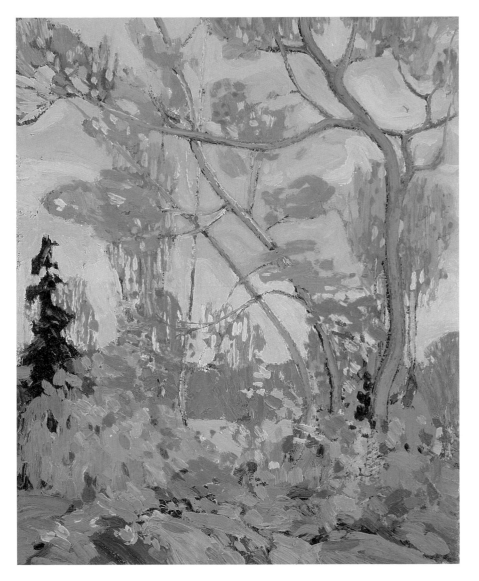

Between September and November of 1915, Thomson was joined in
Algonquin Park by the Varleys, A. Y. Jackson, and the Lismers (who were
shortly to leave for Bedford, Nova Scotia). All of them found their colours
intensifying along with their companionship. Thomson probably painted
this canvas at this time. Beautifully designed, with rich colours, the work
seems to look forward to later canvases by the painter. Here, as in many
other works, his subject is a tree against the shore. Like other trees by
Thomson, this one has an anthropomorphic quality.

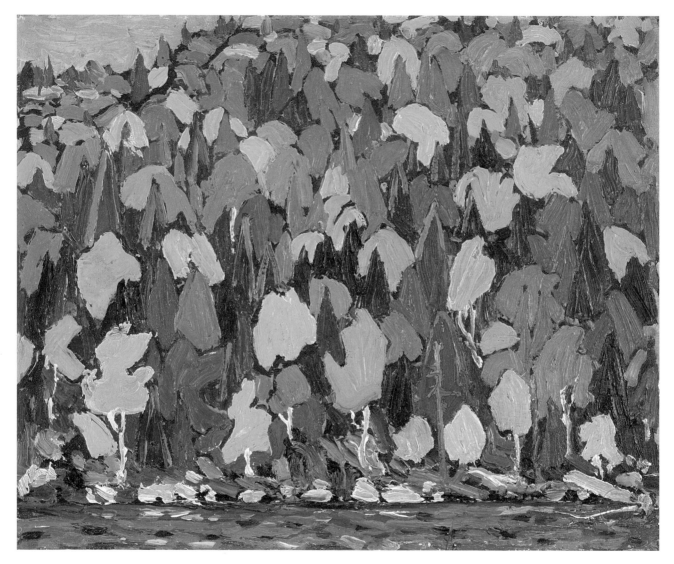

Tom Thomson
Autumn Foliage, c. 1915
Oil on panel
21.6 × 26.7 cm
Art Gallery of Ontario, Toronto
Gift from the Reuben and
Kate Leonard Canadian Fund,
1927

In the fall of 1914 Jackson wrote Dr. James MacCallum that Thomson was showing "decided cubistical tendencies." Varley also wrote that "Tom is rapidly developing into a *new* cubist." This sketch done the following fall shows his cubism for what it was—partly a lesson in broad simplification from commercial art, partly a matter of brilliant colour.

Tom Thomson
First Snow in Autumn, c. 1915
Oil on panel
12.7 × 18.7 cm
National Gallery of Canada, Ottawa
Bequest of Dr. J. M. MacCallum,
Toronto, 1944

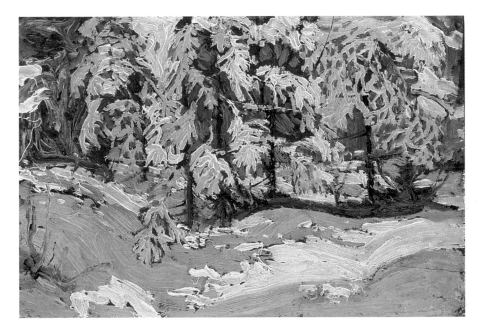

This tiny panel, related to Thomson's *Snow in October* (p. 44), was painted out of doors, as is shown by the random effect of the snow on the trees. Thomson's way of flicking paint on to the panel to suggest trees—as he does at the right—was a technique more like that used by certain contemporary painters than by anyone else in the Group.

The use of such a small size of panel was rare in Thomson's work at this date. In the spring of 1917, when he was short of materials, he used wood for similar-sized panels from Gold Medal Purity Flour cartons.

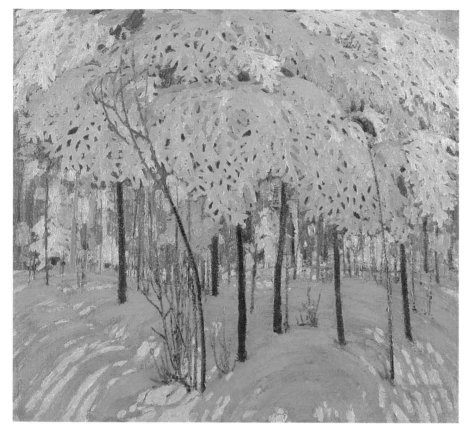

Tom Thomson
Snow in October, c. 1915
Oil on canvas
81.9 × 87 cm
National Gallery of Canada,
Ottawa
Bequest of Dr. J. M. MacCallum,
Toronto, 1944

Tom Thomson was the greatest colourist of the Group. His forte was his ability to combine his training as a commercial artist with a daring use of the painting medium. He had a profound understanding of nature, shown here by the way he compares and contrasts the delicate sapling in the foreground with the tent of snow over the trees in the background. The beautiful way light falls on the snow in the foreground also gives a natural, spontaneous feeling to this scene. The viewer seems to look up to a miraculously beautiful vision. "My debt to him is almost that of a new world, the north country, and a truer artist's vision...," said Jackson.

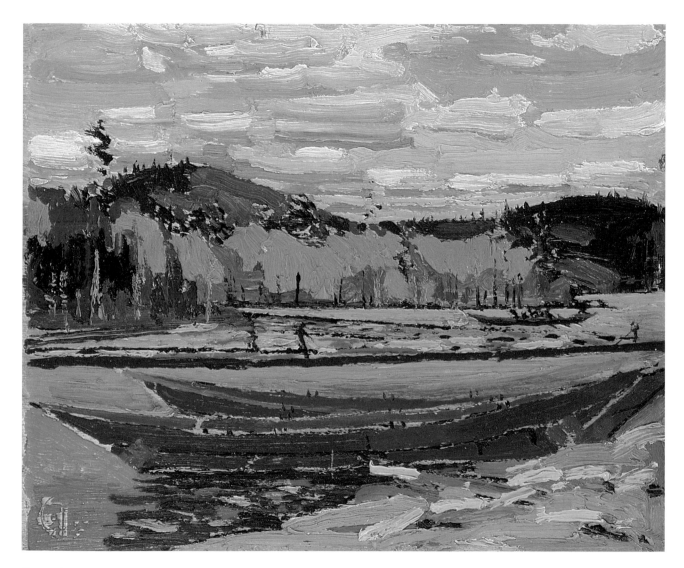

Tom Thomson
Bateaux, c. 1916
Oil on panel
21.4 × 26.7 cm
Art Gallery of Ontario, Toronto
Gift from the Reuben and
Kate Leonard Canadian Fund,
1927

The logging drive was a subject that fascinated all of the Group of Seven. Harris, MacDonald, and Lismer had already done powerful essays on this particular subject. Thomson's painting of *Bateaux* shows the way lumberjacks controlled the flow of the logs. His immensely capable handling of paint is evident in the way he lays colour directly down on the wooden panel and in the way he paints the trees on the distant shore as ghostly wisps.

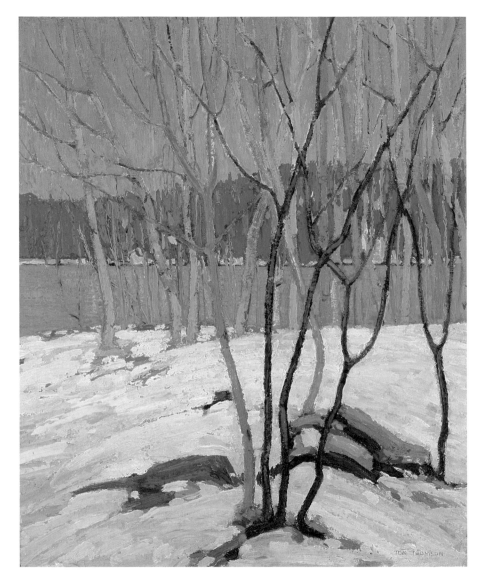

Tom Thomson
*The Birch Grove,
Algonquin Park,*
c. 1916
Oil on canvas
54.6 × 64.8 cm
Private collection, Toronto

Thomson's way of painting snow was to make stained glass of it: here he uses turquoise, pink, and green to express twilight. His trees create a vivid tapestry of colour.

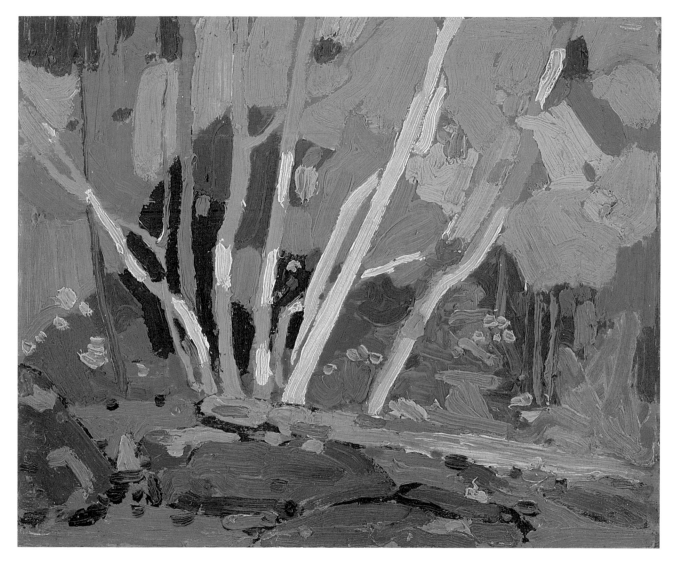

Tom Thomson
Autumn Birches, c. 1916
Oil on panel
21.6 × 26.7 cm
McMichael Canadian
Collection, Kleinburg
Gift of H. P. de Pencier, 1966

At moments in Thomson's work, he veered close to abstraction. Some of the others, like Jackson, thought the direction was dangerous. In 1914, Jackson wrote to MacDonald that Thomson, "plasters on the paint and gets fine quality but there is danger of wandering too far down that road." Jackson always carefully balanced between abstraction and realism himself—and sought a flat, matt effect in paint.

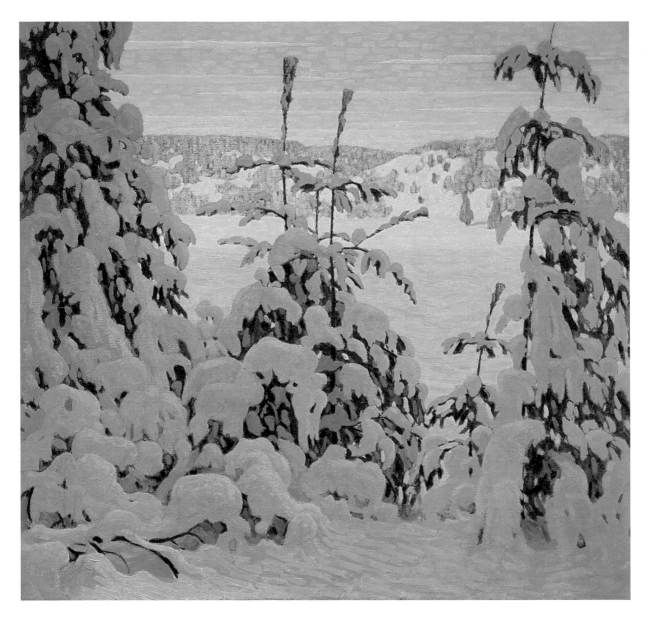

Lawren Harris
Snow (II), c. 1916
Oil on canvas
118.8 × 126.4 cm
National Gallery of Canada,
Ottawa

Harris thought of snow as a substance with more form than Thomson did. His snow is almost sculptural; it has weight. By contrast to the dark, shielded foreground, the light that falls on the background comes as a surprise.

Tom Thomson
The Jack Pine, 1916-1917
Oil on canvas
127.9 × 139.8 cm
National Gallery of Canada, Ottawa

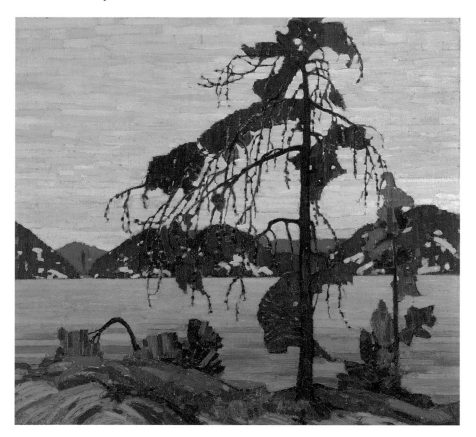

The Jack Pine and *The West Wind* are similar enough in composition, technique and colouring for us to call them a pair. In both, a vermilion red undercoat lies beneath the layers of paint on the trees, hills, and foreground rocks. This undercoat gives the tree forms a throbbing vitality and force, almost as though the colour meant to Thomson the stuff of life itself. Although Thomson's use of red underpainting in *The Jack Pine* gives a curiously alive quality to his depiction, he probably only intended his huge blocks of colour to recall the stained glass of a church. For Thomson, nature was a religion, one which he sought to convey to the viewer.

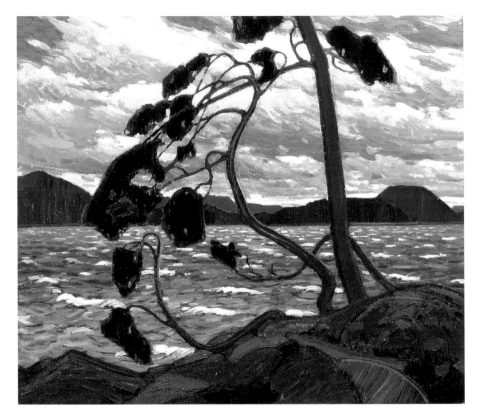

Tom Thomson
The West Wind, 1917
Oil on canvas
120.6 × 137.5 cm
Art Gallery of Ontario,
Toronto
Gift of the Canadian Club
of Toronto, 1926

In this painting, the cut-off silhouette of the *Art Nouveau* tree recalls Japanese art. Its shape, on the other hand, is a poetic metaphor for the tree as the harp of the wind. The theme itself is an ancient one and appeared before in American art, at first as a personification. By the turn of the century, the "West Wind," dematerialized, had become a common landscape subject. *The Studio* magazine showed a scene of sky, cliffs, trees and cattle by J. L. Pickering called *The West Wind's Burden* in 1906. But the immediate inspiration for Thomson's title was probably Lismer's *A West Wind, Georgian Bay*, shown at the OSA in 1916. The innovation in Thomson's *The West Wind* lies in the creation of an image which still bears a powerful message of the forces of nature.

It was said by some that the artist was "grieved" over the painting. He seems to have had trouble with the sky, even to the point of repainting it. An examination of the sky reveals why *The West Wind* canvas will always be a magnificent failure. In his sketch of the subject, Thomson had originally painted a totally different sky, but could not transform its details into the large-scale sky appropriate to the major work.

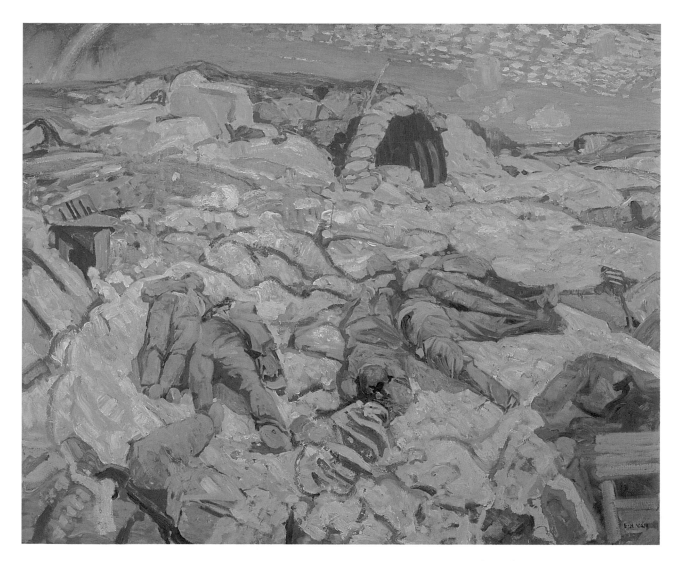

F. H. Varley
The Sunken Road, 1919
Oil on canvas
132.4 × 162.8 cm
Canadian War Museum
National Museum of Man
National Museums of Canada

With the First World War, many members of the fledgling Group of Seven enlisted. Varley worked for the Canadian War Records Department. In *The Sunken Road*, Varley took the figures of the dead men (a German gun crew) from a photograph, the site from an oil sketch. The rainbow in the distance, recalling Jackson's *Terre Sauvage* (p. 39), symbolizes hope for the future as well as satirically commenting on the tragic scene before us. Varley's way of composing on a diagonal into the distance is different and exciting for a member of the Group.

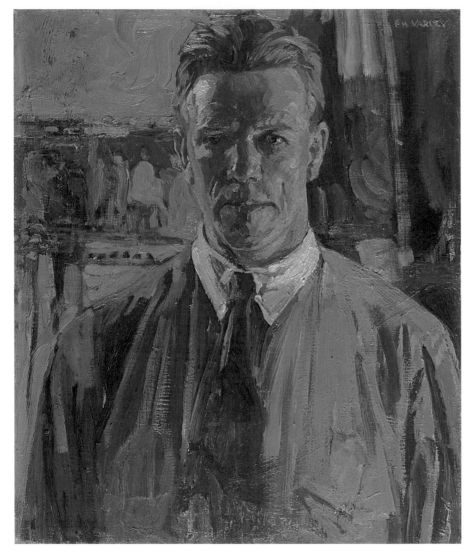

F. H. Varley
Self-Portrait, 1919
Oil on canvas
61 × 50.8 cm
National Gallery of Canada,
Ottawa

In his *Self-Portrait* Varley paints the two sides of his nature, laying his "psychological struggles" before us, as one critic wrote. As the painting demonstrates, he was the best portrait painter of the Group.

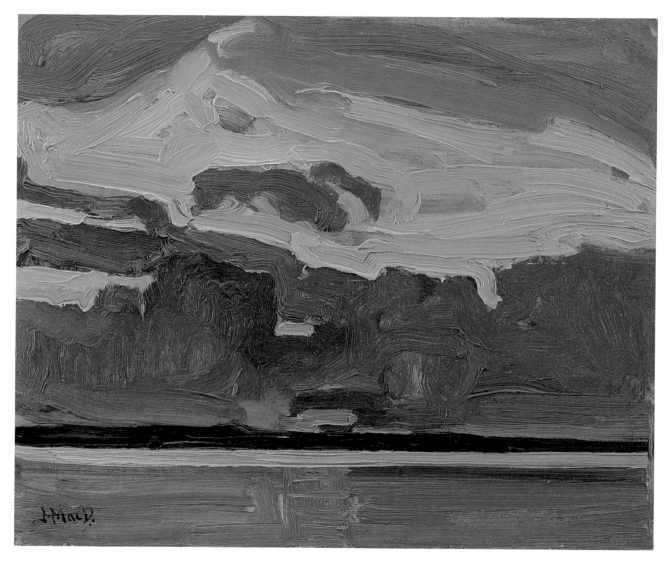

J. E. H. MacDonald
Lake Simcoe, c. 1919
Oil on board
21.3 × 26.4 cm
National Gallery of Canada,
Ottawa
The Vincent Massey Bequest,
1969

At moments, the work of J. E. H. MacDonald could be quite abstract.
He was a master designer, and his sense of design imbues every one
of his works.

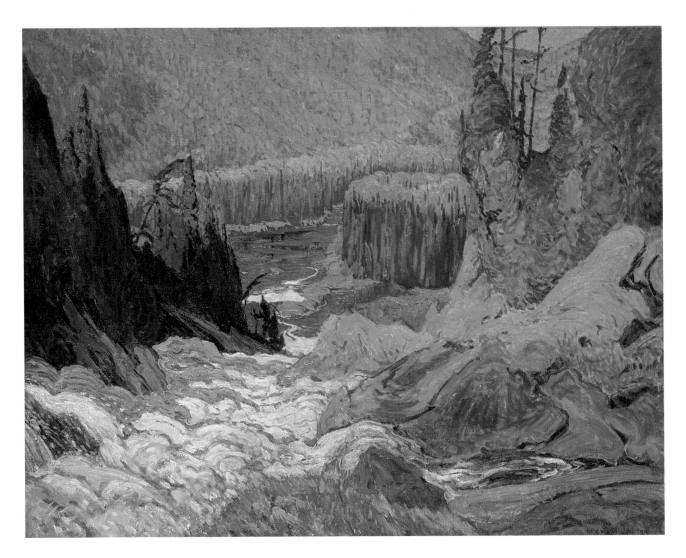

J. E. H. MacDonald
Falls, Montreal River, 1920
Oil on canvas
121.9 × 153 cm
Art Gallery of Ontario,
Toronto

J. E. H. MacDonald felt naturally at home in painting the great vista or panorama. Here his painting seems to extend for several miles into the distance. Comparing the painting with a photograph of the view in Algoma taken under the supervision of MacDonald in 1920, one can see how he emphasized the flat decorative pattern of the scene. He used the background as a backdrop for his excitingly turbulent and patterned style. Note too the unusual hot colours of his hillsides.

A. Y. Jackson
March Storm, Georgian Bay, 1920
Oil on canvas
63.5 × 81.3 cm
National Gallery of Canada, Ottawa
Bequest of Dr. J. M. MacCallum, Toronto, 1943

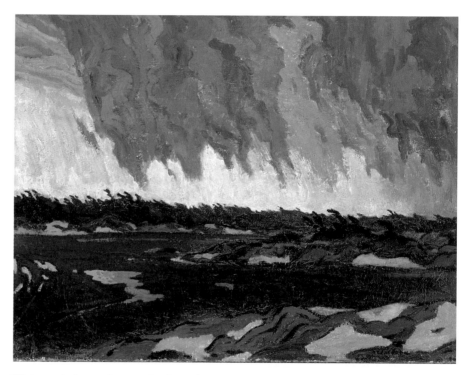

This painting shows Jackson's extraordinary talents: an unusual conception, idiosyncratic trees (here bent by the wind), and broadly painted clouds. The painting is one of the most important and beautiful in his career. Georgian Bay was always one of his "happy hunting grounds," he said himself.

In the same month as Jackson painted this canvas, the Group was formed in Toronto. According to his version of the founding, the first thing he heard when he reached Toronto was that the Group of Seven had been formed, and that he was a member of it. (He probably exaggerated slightly how soon the news reached him).

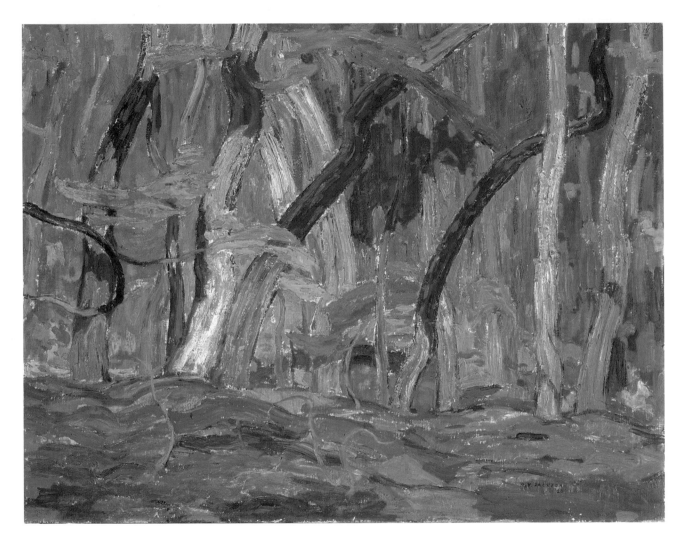

A. Y. Jackson
Maple Woods, Algoma, 1920
Oil on canvas
63.5 × 81.5 cm
Art Gallery of Ontario,
Toronto

Algoma was MacDonald's country, Jackson said, just as Lake Superior was Harris's. As he said himself in his autobiography, *A Painter's Country*, "in October it is a blaze of colour."

Maple Woods, Algoma, with its extraordinary range of reds and oranges and the band of trees laid horizontally across the painting's background, like some rich tapestry design, shows us that Algoma was not only MacDonald's country: it was Jackson's.

J. E. H. MacDonald
Gleams on the Hills,
c. 1920
Oil on canvas
81.3 × 86.4 cm
National Gallery of Canada,
Ottawa
Gift of Mrs. S. J. Williams,
Mrs. Harvey Sims,
Mrs. T. M. Cram, and
Miss Geneva Jackson,
Kitchener, Ontario, 1943

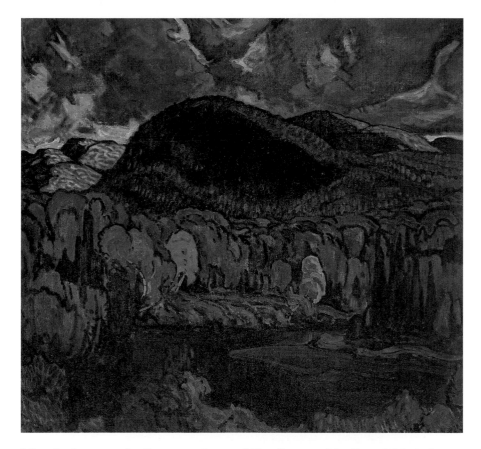

Like Jackson and other members of the Group, MacDonald loved painting the excitement of a storm. He flattens the image by putting red in the immediate foreground and using the same colour on the distant hills. In a lecture in 1929, he spoke of a painter conveying a "more concentrated impression" than natural objects can give. *Gleams on the Hills,* painted from sketches made on the Batchawana River in Algoma, in 1919, is more a rich memory image than an exact record.

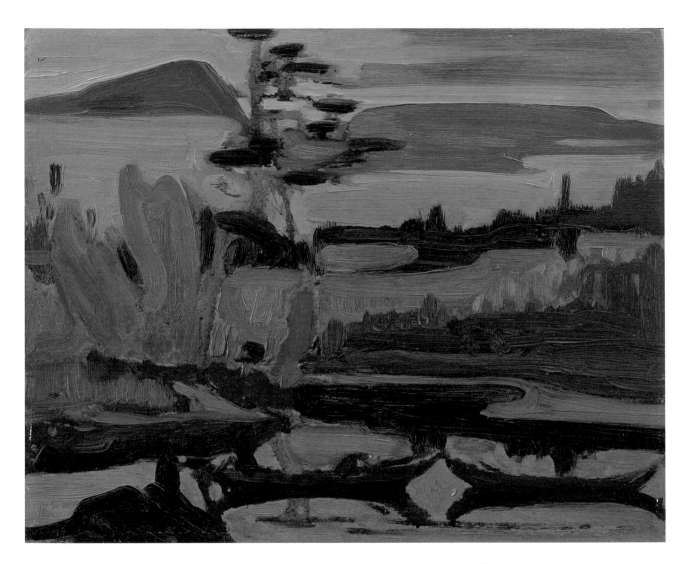

J. E. H. MacDonald
*Mist Fantasy, Sand River,
Algoma*, 1920
Oil on board
21.6 × 26.7 cm
National Gallery of Canada,
Ottawa

One image often introduced by members of the Group was the canoe: they felt their task in painting Canada demanded a new type of artist, one who "paddles, portages and... sleeps in the out of doors," as their friend Housser said.

The canvas MacDonald developed from this sketch (1922, Art Gallery of Ontario) shows how MacDonald used the sketches he made in Algoma in the studio. As a critic noticed in 1965, the finished canvas with its long ribbons of mist is the height of MacDonald's way of stylizing form. Like the sketch, the canvas is as far as he went towards abstraction.

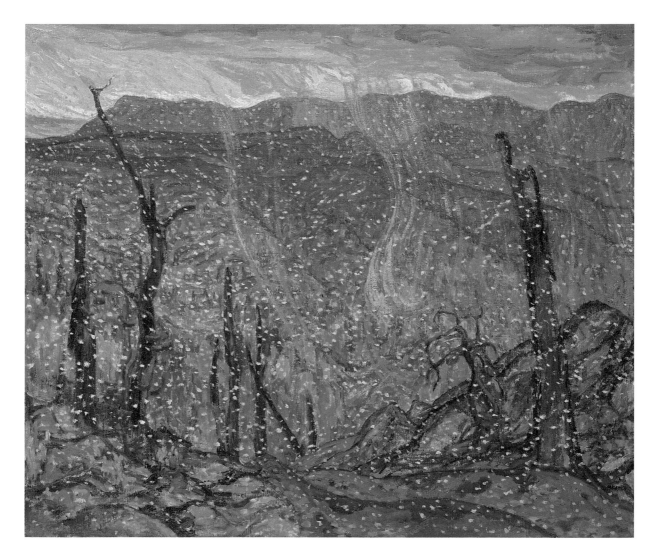

A. Y. Jackson
First Snow, Algoma,
c. 1920-1921
Oil on canvas
107.1 × 127.7 cm
McMichael Canadian
Collection, Kleinburg
In memory of Gertrude
Wells Hilborn, 1966

Jackson's handling of snow as a series of small white flecks spotting the surface of the painting recalls the way Monet painted snow in *Snow at Argenteuil I* (1874, Museum of Fine Arts, Boston). Jackson knew Monet's work: he showed Thomson books on Impressionism.

His painting of Algoma as a scoop of hot-coloured land, which encompasses the viewer, differs from MacDonald's way of painting Algoma as a solemn, big panorama. It was during this period that the identity of the Group was being forged; the communal aims can be seen in the work done at this time.

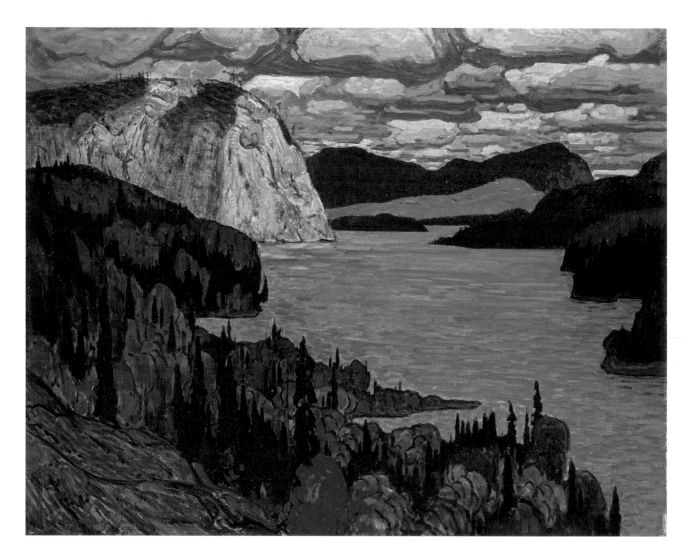

J. E. H. MacDonald
The Solemn Land, 1921
Oil on canvas
121.9 × 152.4 cm
National Gallery of Canada,
Ottawa

MacDonald loved Chinese and Japanese art and recalled certain ways of painting from the Oriental tradition in his work: here in the way he silhouetted his hills and simply massed colour. The lively brushwork is his own. A sketch for the canvas painted on the Montreal River in Algoma is in the collection of the Art Gallery of Ontario.

60

Arthur Lismer
A September Gale, Georgian Bay, 1921
Oil on canvas
121.9 × 162.6 cm
National Gallery of Canada, Ottawa

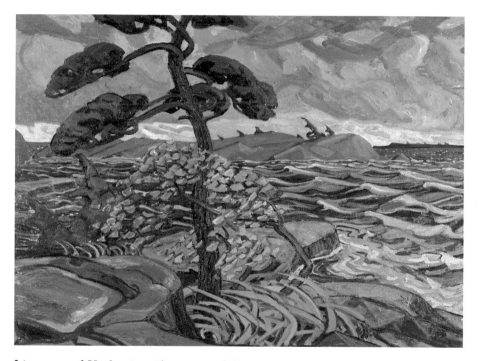

Lismer and Varley together visited Georgian Bay in the fall of 1920, the year the Group was formed. Both developed sketches done during a storm (the men were one hundred feet apart) into major canvases (Varley's was *Stormy Weather, Georgian Bay*, National Gallery of Canada). For both, the single tree blown by the wind recalled Thomson.

Of the two canvases, Lismer's was the greater. He had learned how to move close in, treating his forms as so many sculptured shapes to capture the effect of the storm. Varley showed more of the panorama of the landscape and responded more Impressionistically to the scene. Lismer was the greater designer; Varley the better colourist.

Lawren Harris
Elevator Court, Halifax, 1921
Oil on canvas
96.5 × 112.1 cm
Art Gallery of Ontario, Toronto
Gift from the Albert H. Robson
Memorial Subscription Fund, 1941

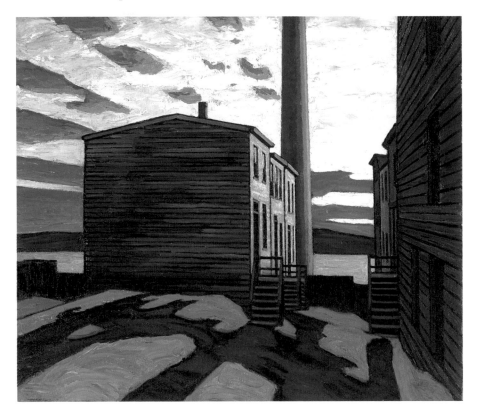

Lawren Harris simplified his work down to essentials. This painting
would seem plain without the thrilling harmony of yellow clouds in the
background and blue snow in the foreground. The gorgeous quality of the
light denies the pedestrian quality of boxy tenement houses.

A yellow-blue polarity had a mystical significance for Theosophists,
a group of which Harris was a member. Yellow was said to represent
intelligence, while blue represented religious feeling. Harris probably had
these equivalences in his mind when he painted the elevator court.

Frank H. Johnston
Nature's Rug, Lake of the Woods,
1921
Oil on cardboard panel
26.8 × 28.6 cm
Art Gallery of Windsor

Johnston's vision of the wilds was a crowded, close-up one,
as though he painted the view nearest him, unlike other members
of the Group.

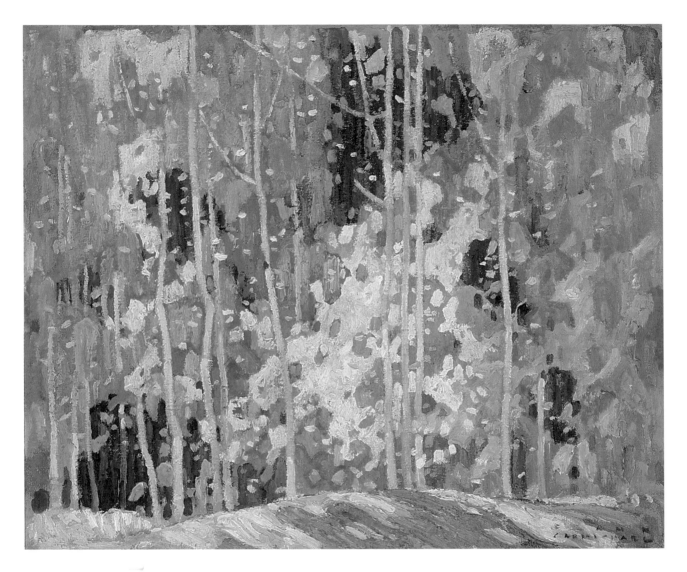

Frank Carmichael
The Glade, 1922
Oil on canvas
63 × 75.5 cm
University College,
University of Toronto

In 1922, Carmichael hit a happy moment in his works, abstracting colour to form a pattern, simplifying form and composition to essentials. *The Glade* expresses his gentle, contemplative nature.

Frank Carmichael
October Gold, 1922
Oil on canvas
119.5 × 98 cm
McMichael Canadian
Collection, Kleinburg

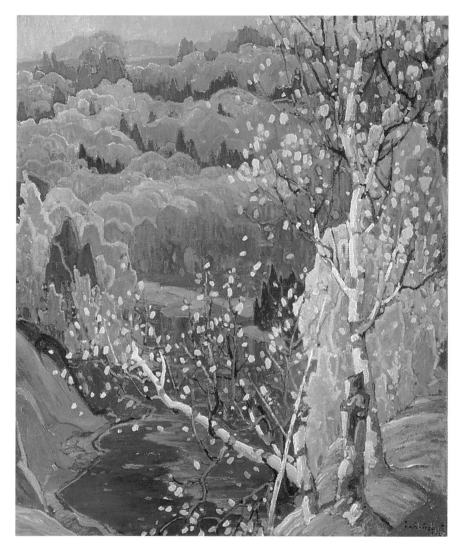

In 1922 Carmichael did two works, *The Glade* and *October Gold*, in which all the elements of his own style came together to beautifully express the aesthetics of the Group. Carmichael's way of painting is more decorative than most of the members'. His rich tones—yellow, gold, orange and red—give the painting life. *October Gold* was painted in the Orillia area where he was born: he must have found the landscape especially congenial.

When the Group of Seven worked out-of-doors, they sketched in pencil and perhaps made an oil sketch. At home in the studio, they developed the sketches into major canvases. Lismer's isles of spruce, which he discovered on a trip to Algoma in 1920 with Harris, Jackson, MacDonald, and MacCallum, is a case in point. Lismer's pencil and oil sketches are rough and indeterminate. The final canvas with its simplified design has many Group features: a twilight sky in the background, a strong, readable organization; dark contours around the rocks; and brilliant colour in the one yellow tree on the island. The pen sketch was completed after the painting.

The canvas is unusually inspired for Lismer, who may have felt uncomfortable with the Group's style. Probably working with Harris, Jackson, and MacDonald made the difference.

Arthur Lismer
Isles of Spruce, c. 1922
Pencil on paper
20.3 × 12.1 cm
Hart House, Permanent
Collection, University of Toronto
Gift of Mrs. M. Lismer Bridges,
1979

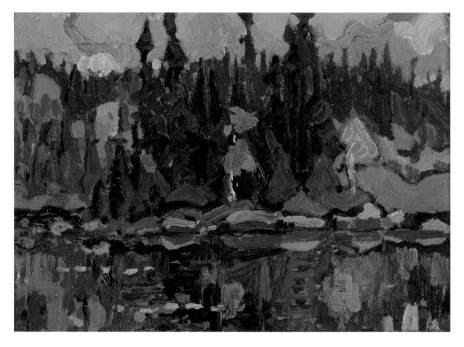

Arthur Lismer
Isles of Spruce, c. 1922
Oil on panel
22.9 × 30.5 cm
Hart House, Permanent Collection,
University of Toronto
Gift from J. Burgon Bickersteth,
1978

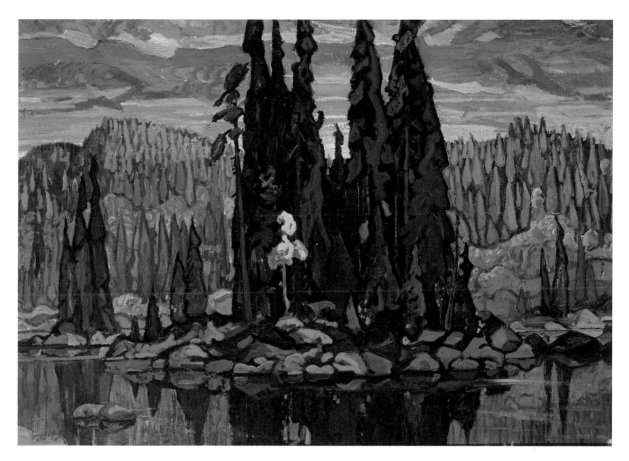

Arthur Lismer
Isles of Spruce, c. 1922
Oil on canvas
119.4 × 162.5 cm
Hart House, Permanent Collection,
University of Toronto

Arthur Lismer
Islands of Spruce, c. 1924-1925
Pen and black ink on wove paper
27.8 × 35.6 cm
National Gallery of Canada, Ottawa

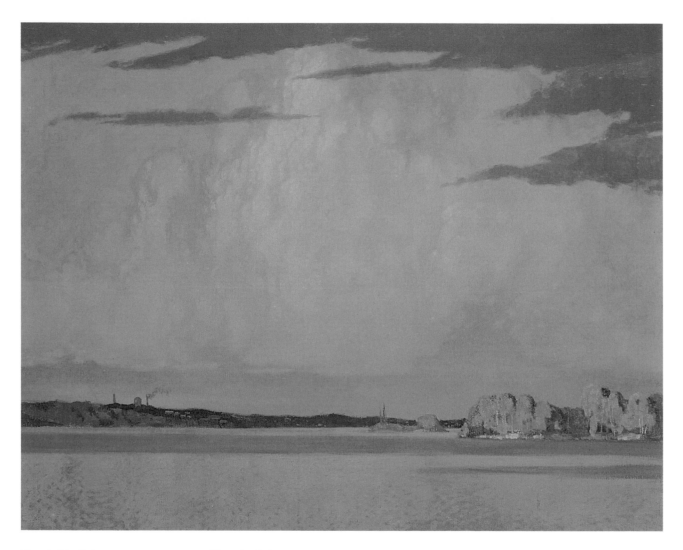

Frank H. Johnston
Serenity, Lake of the Woods,
1922
Oil on canvas
102.3 × 128.4 cm
Winnipeg Art Gallery

Frank Johnston resembled a turn-of-the-century atmospheric painter more than did other members of the Group. This painting, done after he moved to Winnipeg, shows the qualities he found important — a gently handled, modulated portrayal (here, of clouds and their reflection in water).

Lawren Harris
Above Lake Superior, c. 1922
Oil on canvas
121.9 × 152.4 cm
Gift from the Reuben and Kate
Leonard Canadian Fund, 1929
Art Gallery of Ontario, Toronto

Above Lake Superior is Harris's pivotal work, one curator said recently. "No earlier picture prepares us for the clarity of its conception; it marks a new dispensation in his art." Although the effect is austere, the birch stumps in *Above Lake Superior* are so graceful and polished that they recall the bodies of women. Harris's setting is full of grandeur and light as well as being a record of the tiny peculiarities of the landscape—like the Art Deco pattern of the clouds, for instance. The painting and the style Harris evolved at Lake Superior had an important effect on Group members.

A. Y. Jackson
Algoma Rocks, Autumn,
1923
Oil on canvas
81.9 × 101 cm
Art Gallery of Ontario,
Toronto
Bequest of Charles S. Band,
1970

Jackson's paintings with their flat, tapestry-like surfaces, rich colours, and off-beat compositions have an extraordinarily contemporary look. The painting was originally owned by two of the great friends (and collectors) of the Group, Mr. and Mrs. Charles S. Band of Toronto.

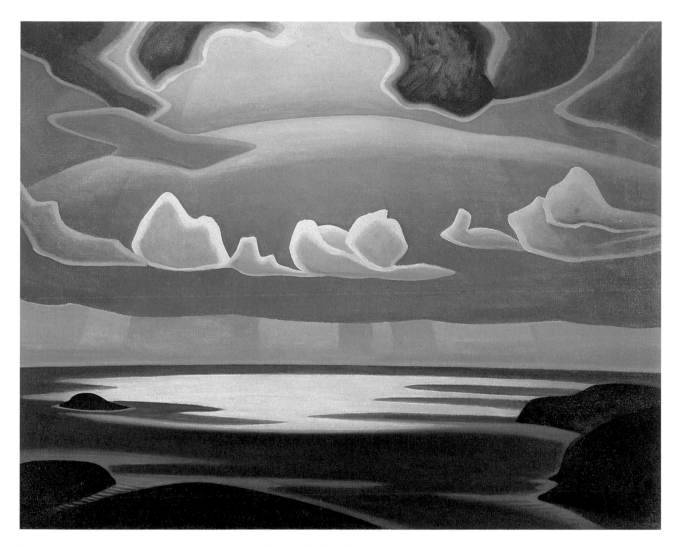

Lawren Harris
From the North Shore,
Lake Superior, 1923
Oil on canvas
121.8 × 152.3 cm
London Regional Art Gallery
Gift of H. S. Southam, Ottawa,
Ontario, 1940

Lawren Harris's clouds sometimes recall white orchids as they float in the sky over Lake Superior country.

L. L. FitzGerald
Pembina Valley, 1923
Oil on canvas
46 × 56 cm
Art Gallery of Windsor
Given in memory of
Richard A. Graybiel
by his family, 1979.

In 1921, after having been honoured by the newly founded Winnipeg Art Gallery with a one-man show, FitzGerald went to New York to study at the Art Students' League. On his return to Winnipeg in 1922, he worked with a stronger sense of form and bolder colour. Works of his from this period and later on impressed Group members so much that they invited him to become a member.

Lawren Harris
*First Snow, North Shore
of Lake Superior,* 1923
Oil on canvas
101.6 × 152.4 cm
Vancouver Art Gallery

Harris echoed the forms of his great canvas, *Above Lake Superior*, in many later works. The following year he painted this canvas as though to try a variation on a theme and show, this time, the first snow. The painting was shown at an exhibition in Toronto in 1923, where Russian artist Leon Bakst saw it; he called it "sculpture rather than painting."

Arthur Lismer
In My Studio, 1924
Oil on card
91 × 76.3 cm
McMichael Canadian
Collection, Kleinburg
Gift of A. J. Latner, 1971

The wind that blows through Lismer's studio is the wind of inspiration, the same one that rocked all the Group's paintings. Portraits like this one show Lismer's vitality and charm.

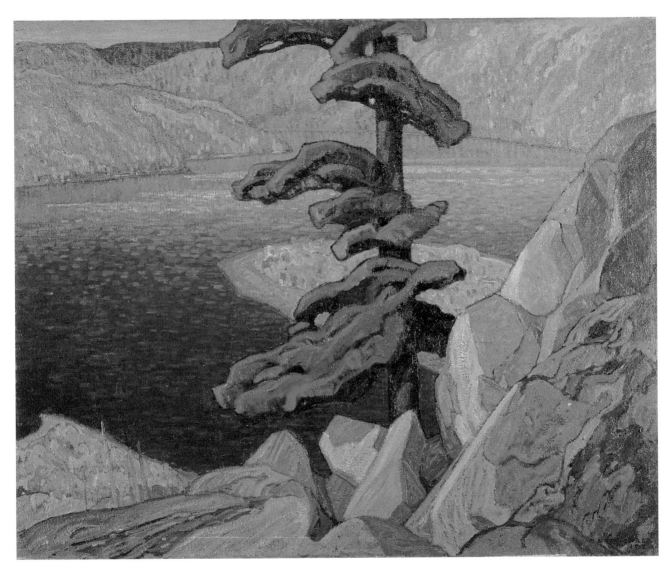

Frank Carmichael
The Upper Ottawa,
Near Mattawa, 1924
Oil on canvas
101.6 × 121.9 cm
National Gallery of Canada,
Ottawa

Frank Carmichael, the youngest member of the Group of Seven, had some difficulty escaping the influence of other members. In its bold formal quality his pine tree recalls Harris, but the way he painted the hills recalls early Lismer, and the rocks recall Thomson. Carmichael's own point of view is shown in the way he situated himself, often on a height of land. He painted the landscape looking down across the vista at his feet.

Lawren Harris
Lake Superior, Sketch II, c. 1924
Oil on board
30.5 × 38.1 cm
Art Gallery of Windsor
Gift from the Douglas M. Duncan
Collection, 1970

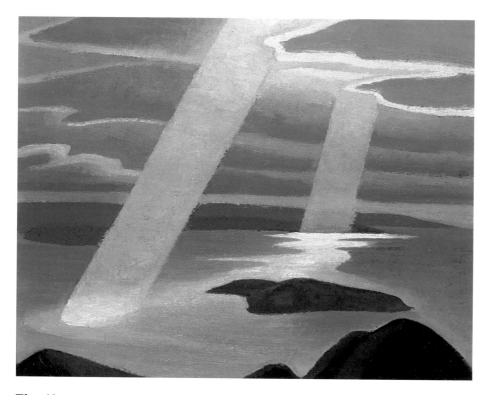

The Algoma country was too opulent for Harris, Jackson said. Harris wanted something bare and stark like the north shore of Lake Superior, much of which had been burnt over years before. "I know of no more impressive scenery in Canada for the landscape painter," said Jackson.

Harris loved the cones or shafts of light in Lake Superior, which burst through the clouds and fall on the water.

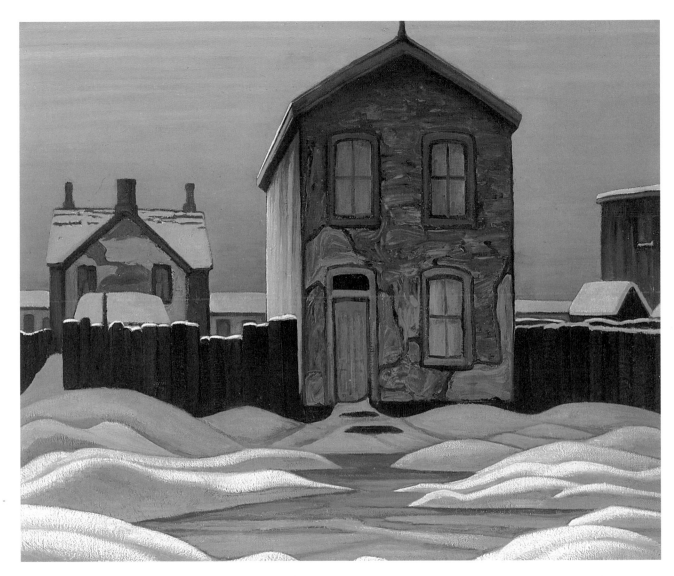

Lawren Harris
Grey Day in Town, c. 1924
Oil on canvas
79.7 × 95.4 cm
Art Gallery of Hamilton
Bequest of H. S. Southam,
Esq., C.M.G., LL.D., 1966

Harris could handle light subtly. A skilled designer, he used light to vary tones in his canvases. Here the light from outside the picture falls on the back of a house in Toronto's Ward area, on the tops of the fence planks, and in the foreground, making an abstract pattern.

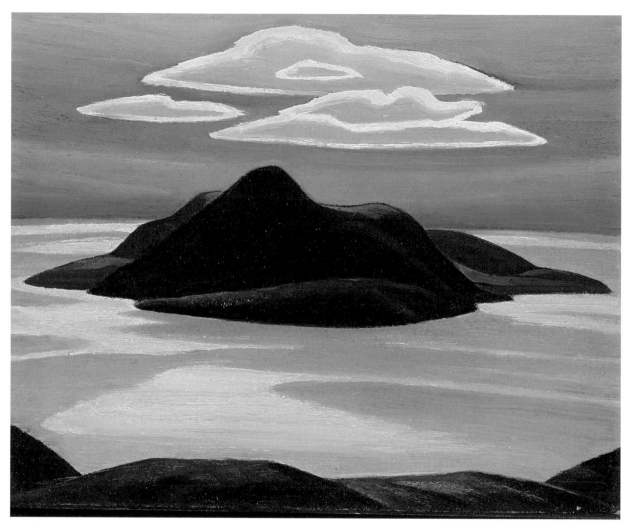

Lawren Harris
Pic Island, Lake Superior,
c. 1924
Oil on panel
20.2 × 38.1 cm
National Gallery of Canada,
Ottawa
Gift from the Douglas M.
Duncan Collection, Toronto,
1970

Many people think of *Pic Island, Lake Superior,* when they think of a Harris work. The gently sloping hills subtly recall the lines of a cat's body. Harris often enjoyed painting this subject.

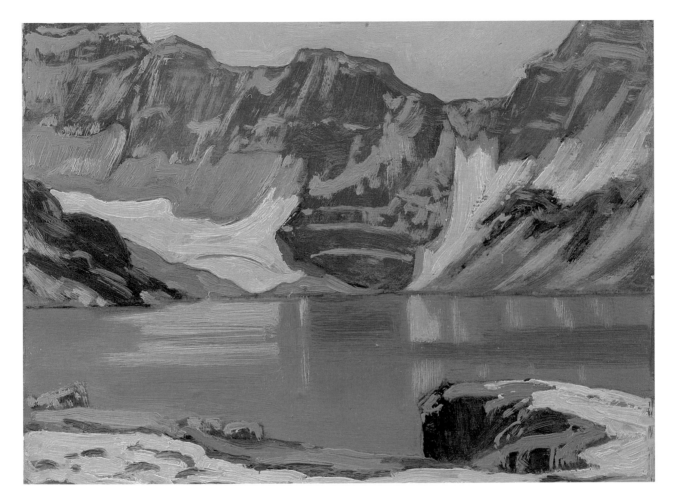

J. E. H. MacDonald
Lake McArthur, Yoho Park,
c. 1924
Oil on board
22.2 × 26.4 cm
National Gallery of Canada,
Ottawa
The Vincent Massey Bequest,
1968

John Singer Sargent noticed a special problem in painting the Rockies: getting in the tops of the mountains. MacDonald has solved the problem by focusing on a scene at the base. His Rockies sketches are among the most beautiful and best designed of his works. They contain contrasts in light: a light sky and snow against dark hills and a blue lake. The grandeur of the subject matter obviously appealed to him. Beginning in 1924, he made seven trips to the Rocky Mountains.

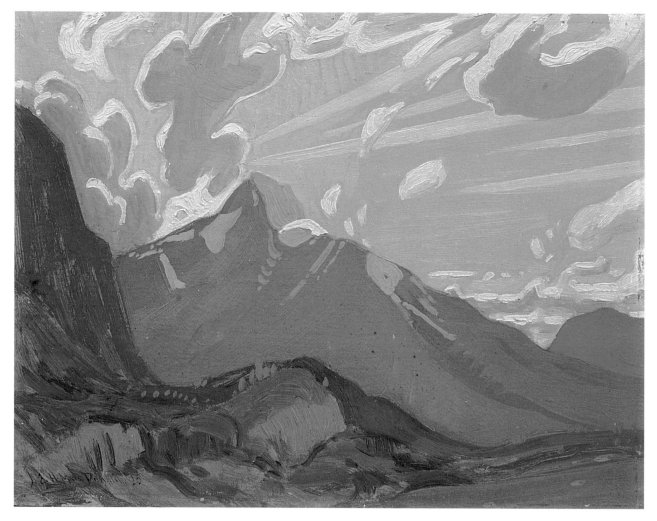

J. E. H. MacDonald
Valley from McArthur Lake,
Rocky Mountains, 1925
Oil on panel
17.7 × 22.8 cm
McMichael Canadian
Collection, Kleinburg
Gift of Dr. and Mrs. J.
Murray Speirs, 1969

MacDonald's background in design helped him with one point of the Group's style: simplification and stylization. Here the cloud formations help focus attention on the mountain peak.

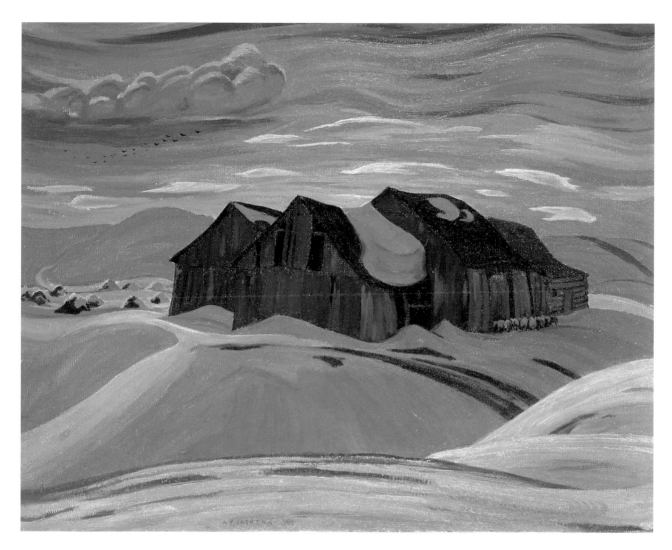

A. Y. Jackson
Barns, c. 1926
Oil on canvas
81.6 × 102.1 cm
Art Gallery of Ontario,
Toronto
Gift from the Reuben and
Kate Leonard Canadian Fund,
1926

Jackson recalled that this group of barns in Quebec was destroyed after he painted it. The landscape is quintessential Jackson: all rolling horizontal rhythms. In some ways, Jackson was like his friend Marius Barbeau, "Canada's most assiduous and enthusiastic gatherer of information about native arts and crafts, early pottery, weaving... and... old songs"—Jackson collected the look of Quebec for future generations.

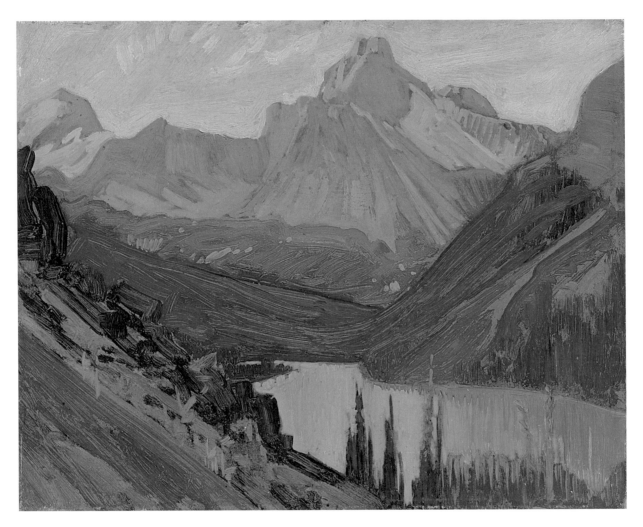

J. E. H. MacDonald
Cathedral Peak,
Lake O'Hara, 1927
Oil on panel
21.4 × 26.6 cm
McMichael Canadian
Collection, Kleinburg
Gift of R. A. Laidlaw, 1966

MacDonald painted the tops of the Rockies in this sketch. To do so, he had to climb a mountain. "Mountain climbers" is one of the descriptions the Group's apologist, writer Fred Housser, applied to the Group.

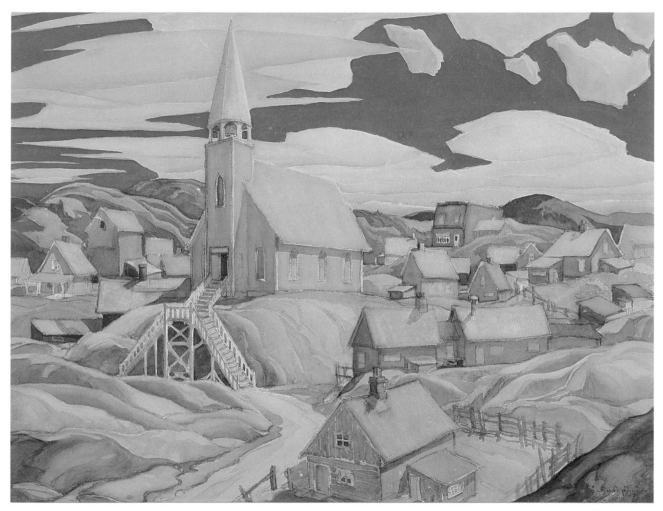

Frank Carmichael
North Town, 1927
Watercolour on paper
55.9 × 71.1 cm
London Regional Art Gallery
Gift of Mrs. Yvonne McKague
Housser, 1945

Carmichael was a master of the watercolour medium. Like his assistant at Rous & Mann, A. J. Casson, Carmichael loved to paint the small towns of Ontario (here Biscotasing, a village on the uppermost reaches of the Spanish River). His clouds give substance and vitality to the scene.

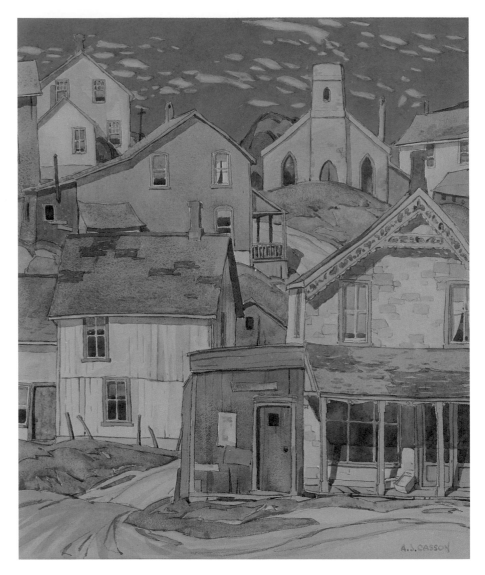

A. J. Casson
Hillside Village, 1927
Watercolour on paper
52.1 × 43.8 cm
Art Gallery of Ontario,
Toronto
Gift from the Reuben and
Kate Leonard Canadian Fund,
1928

In 1926 Casson bought his first car and began exploring villages near Toronto. The Ontario small town was to become his subject *par excellence.* Unlike Carmichael's, his houses have a lived-in look.

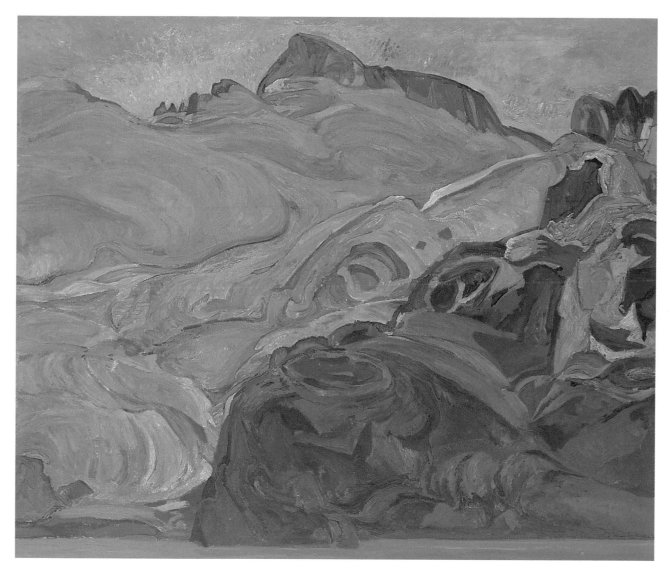

F. H. Varley
Sphinx Glacier,
Mt. Garibaldi, 1927-1928
Oil on canvas
119.4 × 139.8 cm
McMichael Canadian
Collection, Kleinburg
Purchase 1972

Varley's vision of the mountains was the opposite of Harris's. For Varley, the mountains were a molten mass composed of dazzling tints of colours, many of them pastel.

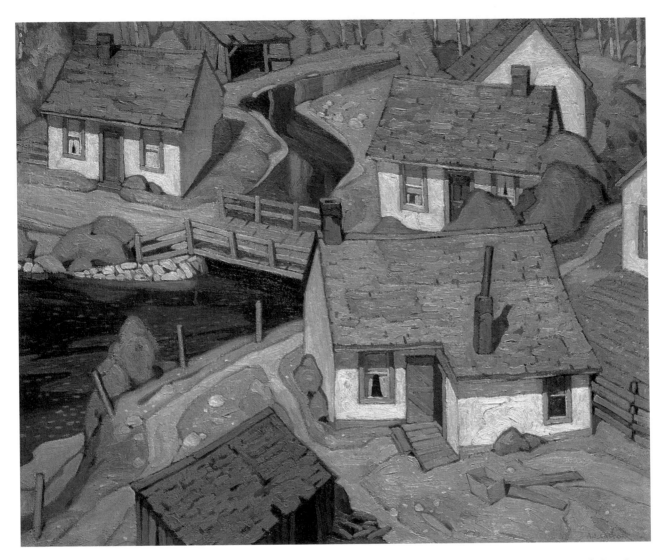

A. J. Casson
Mill Houses, 1928
Oil on canvas
76.2 × 91.4 cm
Agnes Etherington Art
Centre, Kingston
Gift of Mr. and Mrs. Duncan
MacTavish, 1965

Casson had learned to design in commercial art houses of the day. *Mill Houses*, painted from sketches made in the village of Rockwood, Ontario, shows how he applied his training, using the buildings as blocks in abrupt but well-regulated steps down the canvas. The stream echoes the s-curved structure of the composition which is bridged by the section of the painting at left. Casson's work is the stronger for his solid compositional sense.

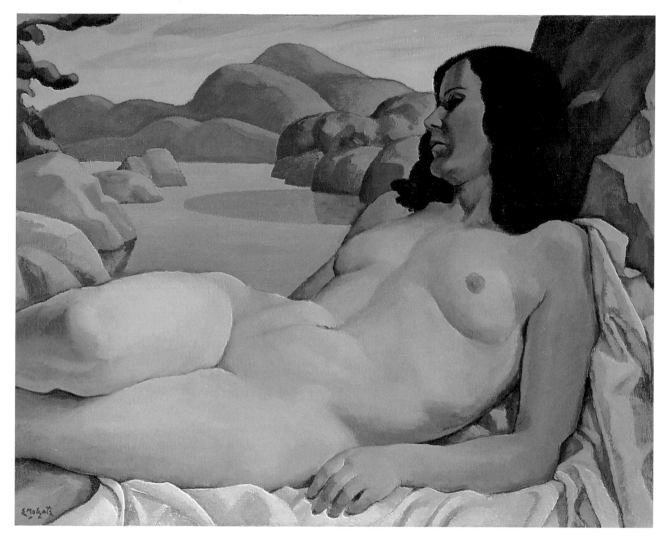

Edwin Holgate
Nude in a Landscape,
c. 1929
Oil on canvas
73.7 × 91.4 cm
National Gallery of Canada,
Ottawa

Holgate painted some of the few nudes by the Group but he was careful to put his subjects in a landscape and to paint them as though they were sculpture—like the hills in the background. His work points to the figure painting that would be done in the next generation by painters such as Pegi Nicol MacLeod whom he taught.

Lawren Harris
North Shore, Baffin Island, 1930
Oil on board
30.4 × 37.8 cm
National Gallery of Canada, Ottawa

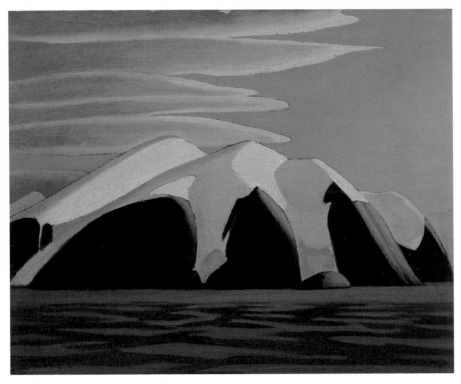

By 1930, Harris's work had acquired a compelling strength based on his bold way of simplifying, his strong colour contrasts, and northern subject matter (in this case in the Arctic). He worked in careful steps of tone and with simple effects of light, but the result is mysterious. Sometimes small sketches like this seem more strongly composed than his larger panels.

Harris's trip to the Arctic in 1930 was the fulfilment of his idea of the North as the centre of spiritual replenishment for the continent. On his return he wrote Emily Carr that he and Jackson, who had travelled with him on the government supply ship *Beothic*, had a "thrilling (at times), monotonous (at times) trip."

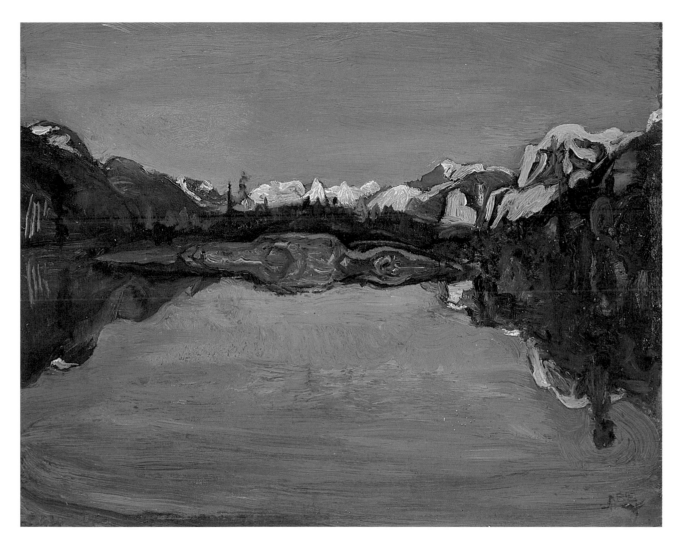

F. H. Varley
Mountain Lake, c. 1930
Oil on panel
30 × 37 cm
Glenbow Museum,
Calgary, Alberta

Varley's way of painting land as a belt between water and sky is exciting. Since there is no foreground, the viewer feels he is looking out of one of Varley's famous windows into the mountain world.

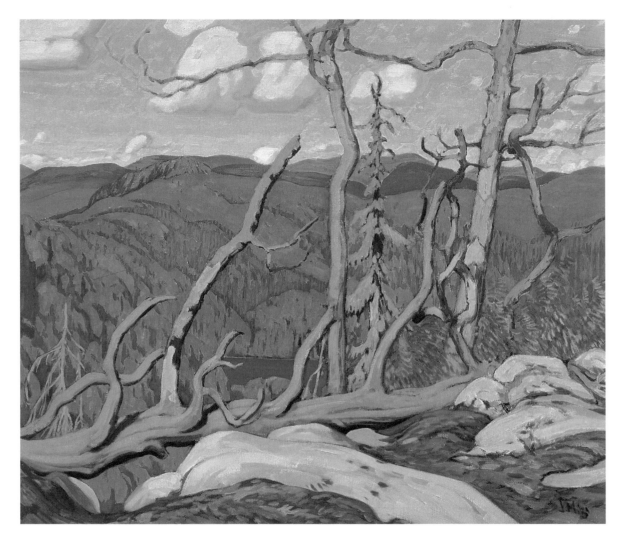

J. E. H. MacDonald
Northland Hilltop, 1931
Oil on canvas
76.2 × 89.1 cm
Art Gallery of Hamilton
Bequest of H. S. Southam,
Esq., C.M.G., LL.D., 1966

In time even MacDonald was influenced by Harris: he may have thought of the foreground trees in Harris's *Above Lake Superior* (p.69) in this painting. But the richly coloured hills with their muted harmonies of pink, green, purple, and orange are his own. So are the puffy clouds in the background, so different from Harris's formalized shapes.

J. E. H. MacDonald
Georgian Bay, 1931
Oil on cardboard
21.5 × 26.7 cm
Robert McLaughlin Gallery,
Oshawa
Gift of Alexandra Luke, 1967

MacDonald painted "cosmic laws" when he painted nature, one writer said. This small fall sketch is imbued with a consciousness and love for God and nature, or God in nature. In November of 1931 MacDonald suffered his first stroke. He died the following year.

F. H. Varley
Lynn Valley, c. 1932
Watercolour and graphite
on paper
17.9 × 25.7 cm
Winnipeg Art Gallery

Atmospheric watercolours were part of the British watercolour tradition, which Varley transformed into an extraordinarily assured way of expressing his own sensibility. His typical vista was a Group of Seven type of panorama: a foreground view with a steep drop to a middle ground, which rises to a mountain background. By 1932, most of the members of the Group of Seven were extending their range to new subjects. *Lynn Valley* must have seemed like the Garden of Eden to Varley: he gives his watercolour an apocalyptic flavour as though he had discovered a world new-born. With these watercolours, his work took a new direction.

Selected Bibliography

Adamson, Jeremy. *Lawren S. Harris: Urban Scenes and Wilderness Landscapes, 1906-1930* (exhibition catalogue). Toronto: Art Gallery of Ontario, 1978.

Bishop, Hunter. *J. E. H. MacDonald Sketchbook, 1915-1922.* Moonbeam, Ont.: Penumbra Press, 1979.

Bridges, Marjorie Lismer. *A Border of Beauty.* Toronto: Red Rock, 1977.

Bridle, Augustus. *The Story of the Club.* Toronto: The Arts & Letters Club, 1945.

Brooker, Bertram, ed. *Yearbook of the Arts in Canada, 1928-1929.* Toronto: Macmillan, 1929.

Brown, F. Maud. *Breaking Barriers.* Toronto: Society for Art Publications, 1964.

Carr, Emily. *Hundreds and Thousands: The Journals of Emily Carr.* Toronto and Vancouver: Clarke, Irwin, 1966.

Colgate, William. *Canadian Art.* Toronto: Ryerson Press, 1943.

Connolly, Cyril. *Ideas and Places.* London: Weidenfeld & Nicolson, 1953.

Darroch, Lois. *Bright Land.* Toronto and Vancouver: Merritt, 1981.

Davidson, Margaret F. R. "A New Approach to the Group of Seven." *Journal of Canadian Studies* 4 (November 1969): 9-16.

Firestone, O. J. *The Other A. Y. Jackson.* Toronto: McClelland and Stewart, 1979.

Glazebrook, George P. de T. *The Story of Toronto.* Toronto: University of Toronto Press, 1971.

Gordon, Robert and Forge, Andrew. *Monet.* New York: Harry N. Abrams, 1983.

Groves, Naomi Jackson. *A. Y.'s Canada.* Toronto and Vancouver: Clarke, Irwin, 1968.

Harris, Lawren S. "The Canadian Art Club." In *The Yearbook of Canadian Art,* pp. 211-216. London and Toronto: J. M. Dent, 1913.

————. *The Story of the Group of Seven.* Toronto: Rous & Mann Press, 1964.

Housser, F. B. *A Canadian Art Movement.* Toronto: Macmillan, 1926.

Hunter, E. R. *J. E. H. MacDonald.* Toronto: Ryerson Press, 1940.

Jackson, A. Y. "Artists in the Mountains." *The Canadian Forum* 5 (January 1925): 112-114.

⸻. "J. E. H. MacDonald." *The Canadian Forum* 13 (January 1933): 136-138.

⸻. "The Origin of the Group of Seven." In *High Flight*, pp. 154-166. Edited by J. R. McIntosh. Toronto: Copp Clark, 1951.

⸻. *A Painter's Country*. Toronto: Clarke, Irwin, 1958.

⸻. "Sketching in Algoma." *The Canadian Forum* 1 (March 1921): 174-175.

Kelly, Gemey. *Arthur Lismer, Nova Scotia, 1916-1919* (exhibition catalogue). Halifax: Dalhousie Art Gallery, 1982.

Kenner, Hugh. "The Case of the Missing Face." In *Our Sense of Identity*, pp. 203-208. Edited by M. Ross. Toronto: Ryerson Press, 1954.

Knox, Peggie Paris. "Personal Reminiscence." In *The Beginnings of Vision: the Drawings of Lawren Harris*, pp. 221-228. By J. Murray and R. Fulford, Toronto: Mira Godard Editions, 1982.

Lochridge, Katherine. *Seven/Eight* (exhibition catalogue). Huntington: Heckscher Museum, 1982.

MacCallum, J. M. "Tom Thomson: Painter of the North." *The Canadian Magazine* 50 (March 1918): 375-385.

MacDonald, J. E. H. "Bouquets from a Tangled Garden." *Toronto Globe*, 27 March 1916.

⸻. *West by East and Other Poems*. Toronto: Ryerson Press, 1933.

MacDonald, Thoreau. *The Group of Seven*. Toronto: Ryerson Press, 1944.

McLeish, John A. B. *September Gale*. Toronto and Vancouver: J. M. Dent & Sons, 1955.

McTavish, Katharine. "Rae Johnson: Pleasure." *C Magazine* 1 (Winter 83/84): 54-55.

MacTavish, Newton. *The Fine Arts in Canada*. Toronto: Macmillan, 1925.

Mellen, Peter. *The Group of Seven*. Toronto: McClelland & Stewart, 1970.

Murray, Joan, "The Art of A. J. Casson." In *A. J. Casson*, pp. 5-13 (exhibition catalogue). Windsor: Art Gallery of Windsor, 1978.

⸻. *The Art of Tom Thomson* (exhibition catalogue). Toronto: Art Gallery of Ontario, 1971.

⸻. *Impressionism in Canada, 1895-1935* (exhibition catalogue). Toronto: Art Gallery of Ontario, 1973.

⸻. *Isabel McLaughlin: Recollections* (exhibition catalogue). Oshawa: Robert McLaughlin Gallery, 1983.

⸻ and Fulford, Robert. *The Beginnings of Vision: the Drawings of Lawren S. Harris*. Toronto: Douglas & McIntyre, 1982.

Nasgaard, Roald. *The Mystic North* (exhibition catalogue). Toronto: University of Toronto Press, 1984.

Reid, Dennis. *The Group of Seven* (exhibition catalogue). Ottawa: National Gallery of Canada, 1970.

⸻. *The MacCallum Bequest* (exhibition catalogue). Ottawa: National Gallery of Canada, 1969.

Robertson [Dillow], Nancy, *J. E. H. MacDonald, R.C.A., 1873-1932* (exhibition catalogue). Toronto: Art Gallery of Toronto, 1965.

Robinson, Mark. Canoe Lake, 1952. Interviewed by Alex Edmison. First carbon copy October 1956.

Robson, Albert H. *Canadian Landscape Painters*. Toronto: Ryerson Press, 1932.

⸻. *J. E. H. MacDonald*. Toronto: Ryerson Press, 1937.

⸻. *Tom Thomson*. Toronto: Ryerson Press, 1937.

Toronto. Art Gallery of Toronto. *A. Y. Jackson Paintings, 1902-1953* (exhibition catalogue). Toronto: Art Gallery of Toronto, 1953.

⸻. *Arthur Lismer Paintings, 1913-1949* (exhibition catalogue). Toronto: Art Gallery of Toronto, 1950.

Varley, Christopher, *F. H. Varley* (exhibition catalogue). Edmonton: Edmonton Art Gallery, 1981.

Varley, Peter. *Frederick H. Varley*. Toronto: Key Porter, 1983.

White, Stewart Edward. *The Forest*. New York: The Outlook Company, 1903.

Winnipeg Art Gallery. *Lionel Lemoine Fitzgerald* (exhibition catalogue). Winnipeg: Winnipeg Art Gallery, 1978-79.

Photograph Credits

The Agnes Etherington Art Centre, Kingston: "Ex Libris: H.L. Rous", p. 14; "Mill Houses", p. 86.

The Art Gallery of Ontario, Toronto: "A. Y. Jackson", photographed by Dr. Maurice Haycock, p. 23; "Algonquin Park, October, 1914", p. 9; "Arthur Lismer", p. 20; "The Group of Seven seated around a table at the Arts & Letters Club", p. 13; "J. E. H. MacDonald", p. 16; "Johnston, Carmichael, Varley, March 1920", p. 11; "Lawren Harris, March 1920", p. 10; "Lawren S. Harris", p. 10.

Canadian War Museum, National Museum of Man, National Museums of Canada, Ottawa: "The Sunken Road", p. 51.

W.O. Crompton, Toronto: "Lawren Harris Exhibition Opening, Oct. 15 – Nov. 14, 1948", p. 22.

Ron Marsh, Glenbow Museum, Calgary: "Mountain Lake", p. 89.

Ernest P. Mayer, The Winnipeg Art Gallery, Winnipeg: "Greeting Card", p. 21; "J.W.G. 'Jock' MacDonald", p. 20; "Lynn Valley", p. 92; "Serenity, Lake of the Woods", p. 68.

The McMichael Canadian Collection, Kleinburg: "First Snow, Algoma", p. 59; "October Gold", p. 65.

The Montreal Museum of Fine Arts, Montreal: "In the Northlands", p. 40.

Tom Moore, Toronto: "Autumn, Algonquin Park", p. 41; "Autumn Birches", p. 47; "Cathedral Peak, Lake O'Hara", p. 82; "From the North Shore, Lake Superior", p. 71; "Georgian Bay", p. 91; "Grey Day in Town", p. 77; "In My Studio", p. 74; "Isles of Spruce" (pencil on paper), p. 67; "Isles of Spruce" (oil on panel), p. 66; "Isles of Spruce" (oil on canvas), p. 66; "Lake Superior, Sketch II", p. 76; "Nature's Rug, Lake of the Woods", p. 63; "North Town", p. 83; "Northland Hilltop", p. 90; "Pembina Valley", p. 72; "Sphinx Glacier, Mt. Garibaldi", p. 85; "The Birch Grove, Algonquin Park", p. 46; "The Glade", p. 64.

National Gallery of Canada, Ottawa: "A September Gale, Georgian Bay", p. 61; "Islands of Spruce" (pen and black ink on wove paper), p. 67; "The Jack Pine", p. 49; "Lake McArthur, Yoho Park", p. 79; "Lake Simcoe", p. 53; "March Storm, Georgian Bay", p. 55; "Mist Fantasy, Sand River, Algoma", p. 58; "North Shore, Baffin Island", p. 88; "Nude in Landscape", p. 87; "Pic Island, Lake Superior", p. 78; "Self-Portrait", p. 52; "Snow (II)", p. 48; "Snow in October", p. 44; "Terre Sauvage", p. 39; "The Solemn Land", p. 60; "The Upper Ottawa, Near Mattawa", p. 75.

Micháel Neill, Ottawa: "First Snow in Autumn", p. 43.

Herb Nott & Co. Ltd.: "Lawren S. Harris and Isabel McLaughlin, British Columbia", p. 22.

Ontario Archives, Toronto: "Tom Thomson", p. 8.

Larry Ostrom, Art Gallery of Ontario, Toronto: "Above Lake Superior", p. 69; "Algoma Rocks, Autumn", p. 70; "Autumn Foliage", p. 42; "Barns", p. 81; "Bateaux", p. 45; "Elevator Court, Halifax", p. 62; "Falls, Montreal River", p. 54; "Hillside Village", p. 84; "Maple Woods, Algoma", p. 56; "The West Wind", p. 50.

Salt Marche Visual Communications: "Gleams on the Hills", p. 57.

Vancouver Art Gallery, Vancouver, "First Snow, North Shore of Lake Superior", p. 73.

2

THE BEST OF THE GROUP OF SEVEN

Design: David Shaw
Editorial: Elizabeth Munroe
Composition: Parker Typesetting Ltd.
Manufacture: Friesens Corporation